BLACK AMERICA SERIES

UNION COUNTY
BLACK AMERICANS

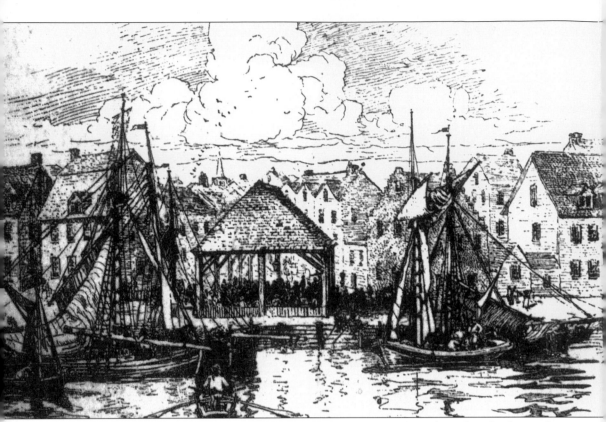

THE SLAVE MARKET AT NEW YORK HARBOR. At the New York and Perth Amboy harbor sides, the Dutch West Indian Company and the Royal African Company, a British slave operation, docked ships filled with West Africans, who were then sold to their first masters in the Elizabethtown region. The two leading slave market harbors were New York and Perth Amboy. The Africans were brought into the region either directly from the Guinea Coast of West Africa or from the Caribbean Islands of Jamaica, Barbados, and Antigua. The two major ships docking in the region were the *Philip* and the *Catherine*.

BLACK AMERICA SERIES

UNION COUNTY
BLACK AMERICANS

Ethel M. Washington

ARCADIA

First published 2004

Published by Arcadia Publishing,
Charleston SC, Chicago IL, Portsmouth NH, San Francisco CA

Printed in Great Britain

Library of Congress Catalog Card Number: 2004108749

For all general information, contact Arcadia Publishing:
Telephone 843-853-2070
Fax 843-853-0044
E-mail sales@arcadiapublishing.com
For customer service and orders:
Toll-free 1-888-313-2665

Visit us on the Internet at www.arcadiapublishing.com

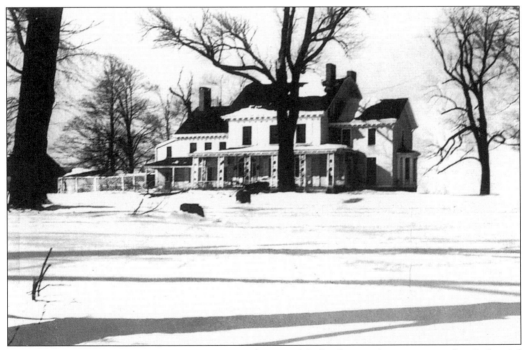

THE HOMESTEAD FARM AT OAK RIDGE, c. 1948. Established as a plantation in the Colonial era by slave holders Shubal and William Smith, the opposite side of present-day Oak Ridge Road included slave quarters and a slave burial ground, as evidenced by oral histories. In the 19th century, the farmhouse served as the lifelong residence of Hon. Hugh Hartshorne Bowne (1814–1881). Judge Bowne, a prominent Quaker abolitionist, New Jersey statesman, and distant cousin to Abraham Lincoln, was active in the Underground Railroad.

CONTENTS

ACKNOWLEDGMENTS

I am deeply indebted to the many Union County organizations and individuals who enthusiastically supported the writing and publication of *Union County Black Americans.* A special thanks goes to the following groups for contributing photographs and information from their collections: Clark Historical Society, Cranford Historical Society, Historical Society of Scotch Plains–Fanwood, Kenilworth Historical Society, Plainfield Historical Society, Springfield Historical Society, Union County Historical Society, Union Township Historical Society, Westfield Historical Society, the Plainfield Public Library, and the Union County Division of Cultural and Heritage Affairs.

It is with pride and respect that I extend my appreciation to the following Union County black senior citizens who contributed photographs and enlightening oral histories: Dorothy Henry, Marge Patterson, Barbara Polk Riley, Donald Van Blake, Rosetta Lattimore, John Watson, Harvey Judkins, Shade and Mary Lee, John Cummins, and Leonard "Bud" Simmons.

For their support and assistance, I thank the following: Alvin T. Hester, James McCauley, Robert Fridlington, Lester Sargent, Michael Yesenko, Walter Boright, Henry Charles, Richard Koles, Sandra Yelenosky, Eleanor Warren, Margaret Bandrowski, and Nancy Piwowar.

I extend very special thanks to my two valued friends, Ann Troupe Thornhill and Rex Nobles, and my son, Jason Daniel Williamson, for their expressions of confidence in my ability to complete this book and for proofing the introductory text.

Finally, I am grateful for having been born to the late Harvey and Essie Lee Parson Washington, who instilled in me a deep sense of pride in my heritage. Their teachings help me realize the timeless message of *Sankofa,* a proverb from the Akan language of Ghana, meaning "One must retrieve the past in order to go forward."

INTRODUCTION

Union County Black Americans is an illustrated history of the African American experience in Elizabethtown and Union County from Colonial to contemporary times. Elizabethtown, established in 1664, was the first English-speaking settlement in New Jersey and the first seat of Colonial government for the state.

The province's first appointed governor, Philip Carteret, arrived in the region on the ship *Philip* in 1664 and stepped ashore at Elizabethtown beside the Arthur Kill, a tidal strait separating New Jersey from Staten Island. From the very beginning, European settlers used and depended upon an enslaved African labor force to work their plantations. Governor Carteret and his 12 followers arrived with 18 African menservants (slaves) because they added value to their land grants.

Governor Carteret also brought with him "The Concessions and Agreement of the Lords Proprietors of New Caesaria/New Jersey," which was the constitution governing the establishment of New Jersey. The document was important to the introduction of African slaves into East Jersey. The original 84 English families settling in the region were encouraged to bring servants and slaves, with offers of an additional 150 acres for each slave and 75 acres for "weaker" servants-slaves more than 14 years old. Bonded servants could get 75 acres after their bondage-servitude ended.

With the legalization and sanctioning of slavery in the province, the Royal African Company took responsibility for the "constant and sufficient supply of merchantable Negroes at moderate rates." (George Fishman, *The African American Struggle for Freedom and Equality.*) The company imported slaves into the Elizabethtown region either directly from the Guinea Coast of West Africa or from the Caribbean Islands of Jamaica, Barbados, and Antigua. Brought over on the slave ships *Philip* and *Catherine* to the two leading slave-trading centers of New York and Perth Amboy, they were marched from the docks to await auction.

As one of the 13 colonies founded for mercantilist reasons, New Jersey depended on the free and forced labor of slaves. Wealthy Dutch planters from Barbados and the New England Puritans used slaves to clear and maintain their sizable land grants, as other slaves toiled on moderately sized land-grant farms of 100 to 200 acres.

Enslaved women labored in households as cooks, laundresses, nursemaids, nannies, and seamstresses. Some worked alongside male slaves as farmhands and gardeners.

Farmland duties included the growing of grains, wheat, rye, and buckwheat. Sheep

and hogs, with some cattle, were the principal interests in animal husbandry. Although early settlers were primarily engaged in agricultural pursuits, they did not organize their agriculture around the cultivation of a staple crop such as tobacco. As a result, these slaves were not usually employed in the work gangs familiar on the plantations in the South. Operators of large mines did employ and find profits in large bound-labor pools.

A significant number of slaves and indentured servants worked as craftsmen and in the skilled trades as bricklayers, blacksmiths, carriage makers, coopers, clockmakers, millwrights, tailors, silversmiths, and paper makers. For example, in 1726, James Roberts, an indentured servant and paper maker by trade, worked at the William Bradford Paper Mill, located on the Elizabeth River. The slave Abraham Hendricks was a cobbler apprenticed to shoemaker and shop owner John Ross, the mayor of Elizabethtown in 1748. Roberts and Hendricks eventually ran away from their masters.

In the 18th century, during Elizabethtown's reign as the seat of government of New Jersey, the black population of the state grew steadily. In 1726, there were 2,581 blacks in a total population of 32,422. In 1738, there were 3,981 blacks and 43,388 whites in the colony. By 1745, the black population had increased to 4,606, while the whites had increased to 56,797. After the middle of the century, the black population grew so rapidly that, by 1790, New Jersey recorded 11,423 slaves and 2,762 free blacks. During this same period, estimates suggest that blacks made up about seven percent of Elizabethtown's population.

The 1840 U.S. Census of Elizabethtown recorded 252 "free colored persons." Of that number, 120 were males and 132 were females, 63 were under 10 years, and the average age was between 10 and 24 years. The total white population was 3,906.

By the mid-1800s, Elizabethtown investors, industrialists, and merchants with deep economic ties to Southern planters and political allies were expressing pro-slavery views. This led to heightened tensions between this group and the abolitionists, sympathizers, and slaves. Free blacks were viewed with suspicion, as natural allies of the remaining slave population. Harsh laws were enacted and penalties were inflicted upon slaves for disobeying and striking their masters, carrying guns, and running away.

The 1804 Act for the Gradual Emancipation of Slaves has been hailed as New Jersey's most important legislation enacted to free its slaves, as well as its most ambiguous. Under this act, signed by Gov. Joseph Bloomfield, then president of the New Jersey Abolition Society, provisions were made for the freedom of every child born to an enslaved mother after July 4, 1804. However, that same law provided that female children were obligated to serve their mother's owner until the age of 21, and male children were obligated until the age of 25. If an owner chose not to enforce this obligation, he or she could abandon the infant to the local overseers of the poor once the child turned one year old and be relieved of further care.

It took the American Civil War and the enactment of the 13th Amendment to bring a definitive end to slavery in Union County and the rest of the state. New Jersey legislators originally rejected passage of the 13th and 14th Amendments and the ratification of the 15th Amendment. New Jersey became the last Northern state to bring an end to the institution of slavery.

Although the Civil War ended the 250-year presence of slavery in America, blacks in Union County, along with the rest of black America, spent most of the next century fighting and working to change a racial system characterized by separation and inequality. The sanctioning of racial discrimination by the U.S. Supreme Court facilitated the systemic denial of political rights, an adequate education, economic opportunities, and equal access to public places and facilities. This official exclusion set the stage and tone for the many decades of civil rights struggles and protest movements launched by blacks in efforts to achieve parity in all segments of their lives.

Acculturation of blacks had already begun by the end of the Colonial period, paving the way for an organized and long-term struggle for equality and justice. The acculturate process is evidenced by the creation of two key institutions in Union County: the black family and the black church. The importation of large numbers of slaves into the region by the end of the 18th century had resulted in significant increases in the number of blacks through procreation. With this increase came a balance in the sexes and the emergence of an early group of black families who were instrumental in the socialization process of younger generations and those migrating from the South.

The black church evolved as the primary religious, educational, social, and cultural outlet for its congregations and the larger community. Clerical followers of the tenets of Philadelphia's Richard Allen, founder of the African Methodist Episcopal Church; Boston's Thomas Paul, founder of the African Baptist Church; and New York's Samuel Cornish, founder of the Colored Presbyterian Church, formed the leadership base of black political and cultural activism.

By the early 20th century, the majority of Union County blacks were segregated into distinct communities. Among this group of communities are the E'port section of Elizabeth, Vauxhall in Union Township, the Jerseyland community in Scotch Plains, the West End of Plainfield, a section of Rahway's Regina district, and in Westfield, from Paulstead to Downer Streets and West Broad Street to South Avenue.

The number of black families in these communities increased significantly during the "Great Migration" period from 1870 to 1910. The American Industrial Revolution was well under way by 1910, which meant better job prospects in Union County. The county became a popular destination for blacks from the upper southern states of Maryland, Virginia, and North Carolina in search of economic opportunity in manufacturing and other popular industries. The outbreak of World War I, a few years later, opened up additional job opportunities for black workers as whites headed off to war.

In 1910, there were 5,353 blacks in Union County. During the period of 1915 to 1940, that number had increased to 17,859. According to the 2000 U.S. Census, the African American populace had reached the all-time high of 108,593. Of the current 21 townships in Union County, the 6 with the largest number of blacks are Plainfield (29,500), Elizabeth (24,090), Roselle (10,917), Union (10,752), Hillside (10,122), and Rahway (7,173).

Union County Black Americans is meant to inform, inspire, and demonstrate how the indomitable spirit of a people can become the source of their self-identification and self-organization. It is the author's hope that this brief historical account will encourage further research on this topic and serve as a reference guide and supplement to lessons taught in elementary, middle, and high schools throughout the county.

Finally, it is important to note that I have chosen to use the nomenclature "black" because it best describes one of the two groups of non-native settlers in the region, whites being the other, related by their respective African and European common descents. Black and white Americans are also the only two groups traditionally classified, in the United States, on the basis of their physical characteristics or genetic markers.

One

IN THE BEGINNING

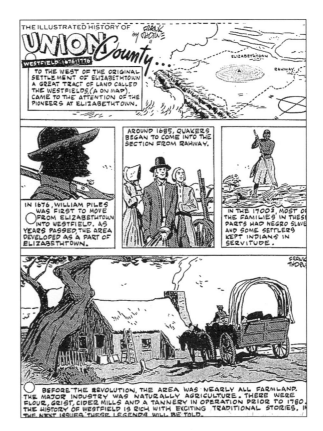

THE *DAILY JOURNAL OF ELIZABETH*, JULY 9, 1970. This newspaper strip by Frank Thorne illustrates life in Westfield during the period of 1676 to 1776. In scene three, above right, he mentions the prevalence of slavery among some settlers.

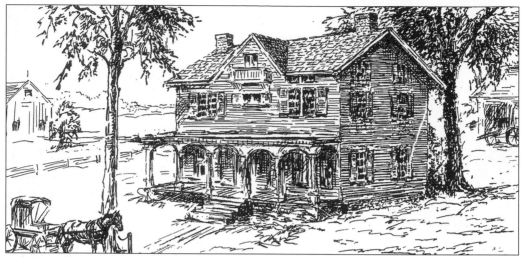

THE SAMUEL DOWNER STORE, WESTFIELD. Shown above is a rendering of the old Samuel Downer (1760–1846) store. James T. Pierson bought the store in 1882, moved it to its present site at 617 East Broad Street, and converted it into the attractive residence it is today. The residence was the birthplace of his son Arthur, who would later develop the Stanley Oval nearby (see page 13).

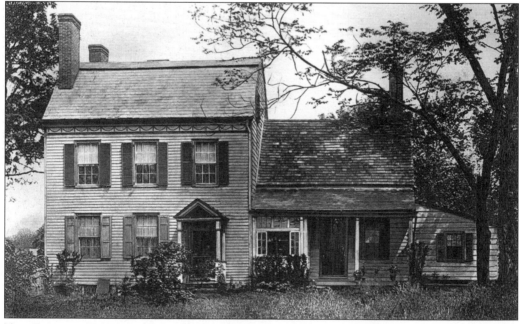

THE PIERSON HOMESTEAD–STANLEY COTTAGE. In 1885, Capt. John Sansom bought the Westfield residence (built in 1801) of Theophilus and Oliver M. Pierson. He named it Stanley Cottage after the noted African explorer Henry M. Stanley. Captain Sansom, a slave trader, was skipper of the fruit steamer *Adirondock*, which plied between New York and the West Indies.

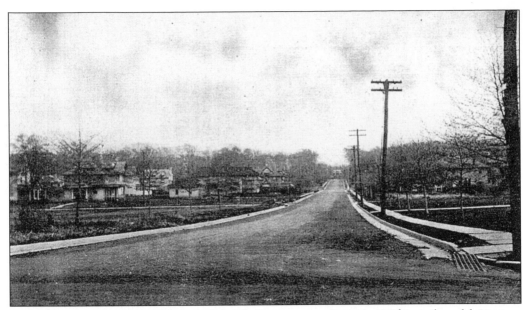

THE STANLEY OVAL, WESTFIELD. Arthur N. Pierson was born in 1867 at the old Pierson Homestead. He later developed the Stanley Oval in honor of African explorer Henry M. Stanley. Pierson was a member of the New Jersey State House Assembly from 1915 to 1922, where he served as Speaker of the House in 1919. He was the New Jersey state senator from Union County from 1923 to 1932.

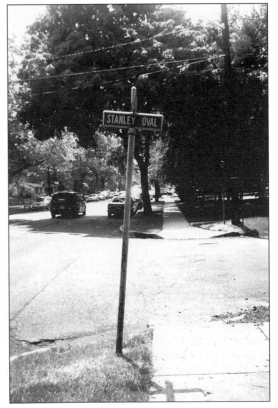

THE VIEW FROM BROAD AND STANLEY AVENUE. This Stanley Oval street sign stands on the corner of Broad Street and Osbourne Avenue as one enters into the Stanley Oval, known today as a cul-de-sac.

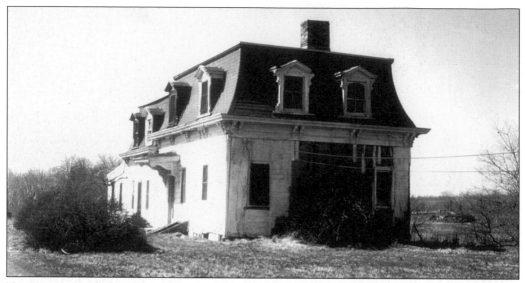

THE GEORGE LOESER HOUSE, CLARK. The George Loeser House was built in 1732 by the seaman and slave dealer Captain Brown. Loeser was a prosperous vegetable farmer from Connecticut who purchased this property in the mid-1890s. Legend states that the house had served as an Underground Railroad station for escaping slaves prior to the Civil War. Located near the Rahway River, it was torn down in the 1950s.

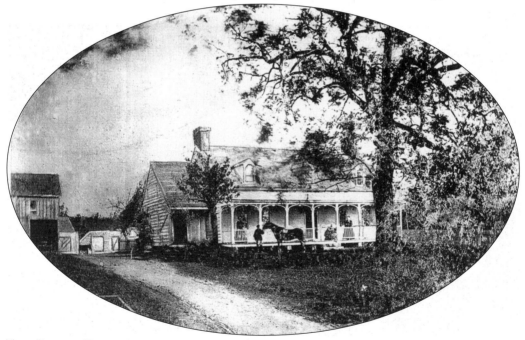

THE GIDEON ROSS ESTATE, WESTFIELD. Slavery existed throughout the Elizabethtown region during the American Revolution. John Erskine, the first settler in the immediate limits of Westfield in 1695, drew the above lot, No. 143, of the 100-acre lots in the West Field. By 1839, John Ross, mayor of Elizabethtown in 1748 and father of Gideon Ross, lived on this estate. Oral history recordings of old Westfield families tell of slave quarters here.

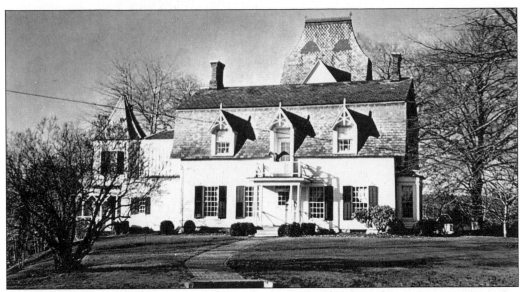

THE DRAKE HOUSE MUSEUM, PLAINFIELD. In 1746, Isaac Drake built the above structure, formerly a one-and-a-half-story farmhouse, for his son Nathaniel. The Drake family owned several slaves, including those identified by first names only: Caesar, Tone, Isiah, and Cate. The Drake House Museum, as it is known today, was renovated in 1865, and the towers were added in 1920. It is now a public museum administered by the Historical Society of Plainfield.

THE PETERSON HOUSE, CLARK. This house was constructed *c.* 1778 by slave trader Capt. Samuel Smith, an Elizabethtown tavern keeper. Queen Anne, dissatisfied with the financial returns of the colony, had introduced and encouraged slave trading as a means of increasing her revenues, despite the fact that many of the Quaker settlers in the area were bitterly opposed to slavery. Smith reportedly ordered a subcellar built under the main cellar to hide his slaves.

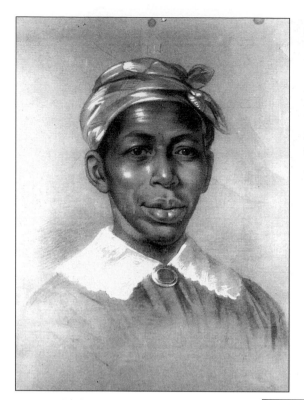

JUDE (1812–1854). Enslaved by the age of three, Jude was a servant in a house on the 100-acre estate of John Denman, the first white settler in that part of the West Fields of Elizabethtown, now known as Cranford. She spent her entire life in the service of the Denman family. Jude is buried in the Denman family plot in Westfield's Fairview Cemetery with the tombstone inscription "A faithful and beloved servant."

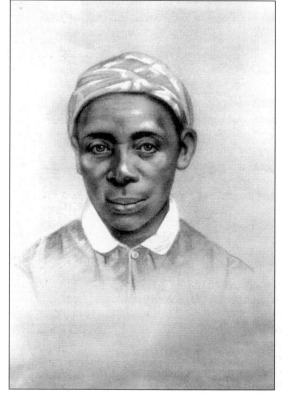

SARAH. Like her mother, Jude, Sarah was born after the New Jersey legislature passed the Act for the Gradual Emancipation of Slaves in 1804. Under this act, children born to an enslaved woman after July 4, 1804, were free. However, the law provided that female children were obligated to serve their mother's owners until the age of 21. Neither Sarah nor Jude was positively affected by this law, as they remained in service to their owners, the Denmans.

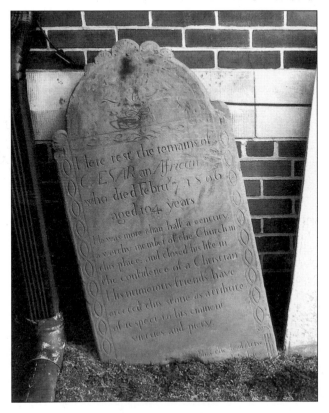

THE GRAVE SITE OF AMBO (1747–1847), RAHWAY CEMETERY. It was not unusual for slave owners to bury their slaves in the family plot. Ambo was an African-born woman who was a slave to three generations of the Abraham Terrill family in Rahway. The name Ambo is derived from the Hausas, a large group of Africans found in the West African nations of Nigeria and Niger.

THE GRAVE OF CAESAR (1702–1806), SCOTCH PLAINS CEMETERY. Caesar was born in Guinea, West Africa, in 1702. Enslaved as a young child, he was imported to the Elizabethtown region. His first master, Isaac Drake, "willed" him to his son Nathaniel Drake of Plainfield. Caesar, a wagoneer in the American Revolutionary War, joined the Scotch Plains Baptist Church along with his master. Although most eloquent in prayer and famous for his exhortations, he was denied deacon or church officer status because of his color.

SUSSEX

PASSAIC

BERGEN

WARREN

MORRIS

ESSEX

HUDSON
Jersey City

UNION

Rahway New York City

HUNTERDON

Perth Amboy

SOMERSET

New Brunswick

Princeton

MIDDLESEX

MERCER

MONMOUTH

Trenton

Bordentown

Mount
Holly

Philadelphia

BURLINGTON

OCEAN

Camden

GLOUCESTER CAMDEN

Woodbury Evesham

Swedesboro

SALEM

Salem

ATLANTIC

Greenwich

CUMBERLAND

Dover, DE

CAPE MAY

—— **LINE 1: Camden to New York City**
—— **LINE 2: Salem to Bordentown**
—— **LINE 3: Greenwich to Mount Holly**
—— **LINE 4: Trenton to New York City**

THE UNDERGROUND RAILROAD. Although no conspicuous Underground Railroad routes existed in Union County, minor, diversified routes led into the county. When the crossing at New Brunswick was safe, Underground passengers were brought directly into Rahway, where fresh horses were waiting to start for Jersey City, the last station in New Jersey. Because of the high concentration of Quakers living along the Rahway route, there were many houses and barns to give shelter when warning came. In the event of danger north of the Raritan River, detour routes eventually led around Rahway to Elizabethport. The upper region of the Delaware Valley had a route that started at Phillipsburg, then to Somerville, to Elizabeth, and finally across to Staten Island. (Courtesy New Jersey Heritage magazine.)

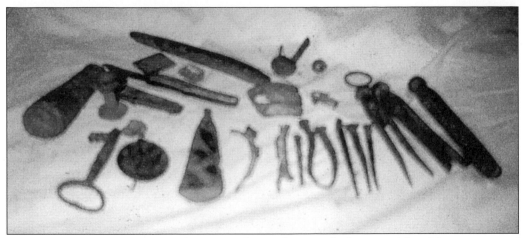

TANGIBLE MATERIAL REMAINS. The items shown here include animal food bones, carved wooden pieces, handcrafted clothespins, and other items found beneath the wide-planked floorboards on the second floor of the historic Cannon Ball House in Springfield. These remains are viewed by some archaeologists as evidence of a slave presence.

THE CANNON BALL HOUSE OF SPRINGFIELD, C. 1741. Listed on the both the New Jersey and National Register of Historical Places, this house, through the investigative study of material remains such as those shown above, reveals much about the living conditions, material possessions, and cultural conditions of 19th-century blacks.

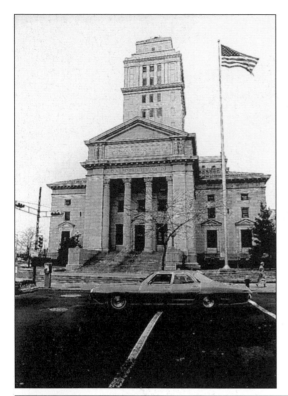

THE UNION COUNTY COURTHOUSE, ELIZABETH. In 1741, as the antislavery movement gained momentum and slave rebellion increased, white hysteria over rumors of a slave uprising led to the "burning at the stake" of three blacks at the site of the present Union County Courthouse. Sheriff William Chetwood was in charge of the burning. Records show that townsmen Daniel Harrison, Joseph Heden, Isaac Lyon, and Tophar Beech received pay "for carting" and furnishing the wood for the burning.

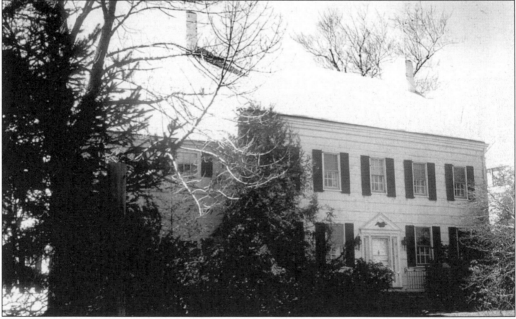

THE GEORGE HARTSHORNE FARMHOUSE. George Hartshorne was cousin to Judge Hugh Hartshorne Bowne. This farmhouse, one of the earliest in Clark, was built by the Hartshorne family in 1690. It is said to have been the site of an Underground station for escaping slaves in the later years of slavery, just prior to the Civil War. The original part of the house still stands and is flanked by a heavy chimney on each end.

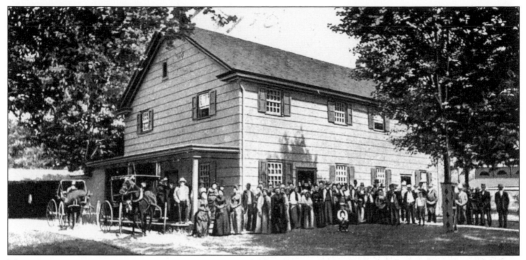

THE FRIENDS MEETINGHOUSE, PLAINFIELD. This 1910 postcard shows both black and white members standing in front of the Friends meetinghouse, built between 1787 and 1788. As evidenced in early minutes dating as far back as 1686, members of the Society of Friends held ambivalent views on slavery. Society member and abolitionist Aaron M. Powell held his antislavery meetings at the Plainfield home of Joseph and Mary W. Post when the meetinghouse was "closed against them."

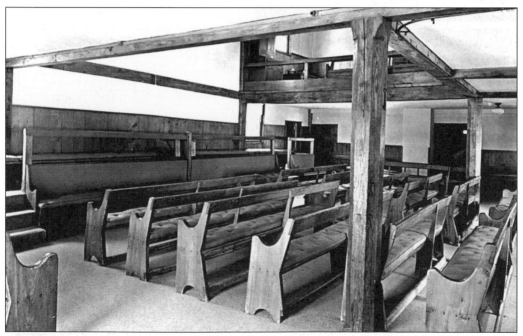

AN INTERIOR VIEW OF THE MEETINGHOUSE, PLAINFIELD. The Plainfield Society of Friends was not free of racial prejudice. Blacks were required to sit in a special place against the wall, under the stairs, or in the gallery. It was also difficult for blacks to become members. In 1796, Cynthia Miers, identified in society minutes as a mulatto woman, requested membership. Her request was granted a year later, when the New York Meeting ruled that local societies should receive members "without respect of persons or colour."

of my Son Isaac) to be paid by my Executors or the Survi=
vor of them as afores: out of my Personal Estate. And
all the residue & remaining part of my Personal Estate
I order to be equally divided between my four Children
as namely Samuel Daniel and Nathaniel Drake and
Hannah Lang Thap Share alike. It is my Will
& I do hereby order that Cate my Negro Wench be
set at liberty at my deceas as a free woman & never
more to be confined or claim'd as part of my Estate, it
is my Will and I do hereby order that my three Negro
men as namely Tom Cesar and Tone be set at
liberty at the expiration of Ten years after my deceas
and never after to b' confined as Slaves or as any part
of my Estate And I do hereby order my Executors herein
after named to take care of my afores: Negroes (after they
are free) that they dont become a charge to any Town
or Parish. And Lastly I do hereby nominate constitute &
appoint my beloved Sons Samuel Drake & Daniel Drake Executors
of this my last Will & Testament giving them full Power to
act in & about the Premises And I do hereby revoke disanul
& make void all former & other Wills by me at any time
heretofore made ratifying & confirming this & no other to be
my last Will & Testament In Witness whereof I have hereunto
Set my hand & Seal the third day of January in the year of
Our Lord One thousand Seven hundred & fifty Six, the word (paid)
in the fourteenth line from ye top first interlined. Isaac Drake (LS)
Signed Sealed published pronounced & declared by the Testator as his
last Will & Testament, Jeremiah Manning, James Manning

THE LAST WILL AND TESTAMENT OF ISAAC DRAKE, 1756. Some slave holders determined the fate of their slaves in their last will and testament. Isaac Drake willed his three male slaves—Tom, Caesar, and Tone—to his son Nathaniel Drake of Plainfield. He ordered that all three be granted permanent freedom 10 years after his death. He furthered ordered "that Cate my negro wench be set at liberty at my decease as a free woman and never more be confined or claim'd as part of my estate." Isaac Drake also willed Cate four pounds, six shillings, and eight pence from his personal estate.

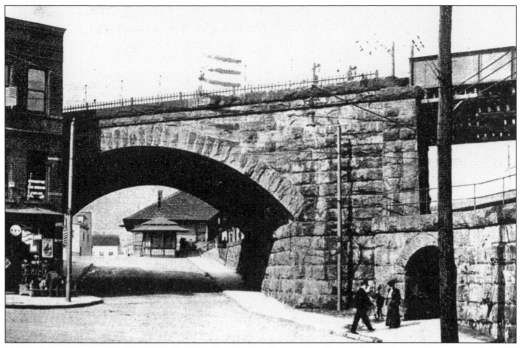

THE ELIZABETHTOWN DEPOT TRAIN STATION. Pres. Abraham Lincoln was greeted by a group of Union County dignitaries and friends at the Elizabeth train station on February 21, 1861, as he made his way to Washington, D.C., for his inauguration as the 16th president of the United States. Lincoln spoke to the group from the platform of his special train. (Courtesy Charles Aquilina.)

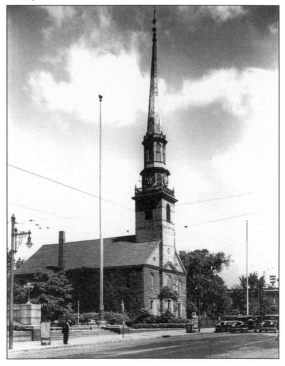

THE FIRST PRESBYTERIAN CHURCH OF ELIZABETHTOWN. In 1854, the Elizabethtown chapter of the African Colonization Society held its organizational meeting in the First Presbyterian Church of Elizabethtown. Leaders of the New Jersey State Society declared it the duty of all Christians "to help Negroes" get to Africa by raising money needed to establish an iron industry in Liberia, an African colony under New Jersey state sponsorship.

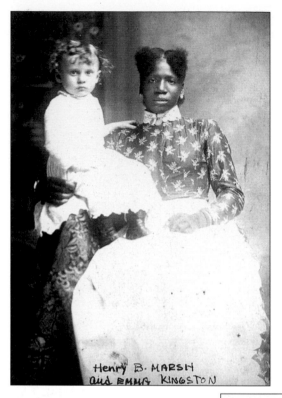

Henry B. MARSH
and EMMA KINGSTON

EMMA KINGSTON WITH HENRY B. MARSH,
c. **1900.** Throughout the 18th and
19th centuries, black women served as
nannies or caregivers to the children
of their wealthy white employers while
raising their own children at the same
time. Emma Kingston, who worked on
the Marsh family estate in Scotch
Plains, is shown here holding Henry B.
Marsh, a descendant of slave owner
John Marsh.

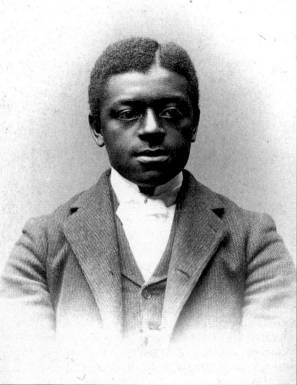

HENRY SHENCK, *c.* **1890.** Here,
Henry Shenck is dressed in his
Sunday best. He was a servant
on the John Marsh estate, at the
corner of Park Avenue and
Front Street in Scotch Plains.
John Marsh was chairman of the
township committee from 1879
to 1882, and again in 1884. The
Marsh house was later razed
and replaced with the Scotch
Plains Municipal Building.

HENRY SHENCK, *C.* **1900.** In this later photograph, Henry Shenck strolls with a basket or bucket filled with food.

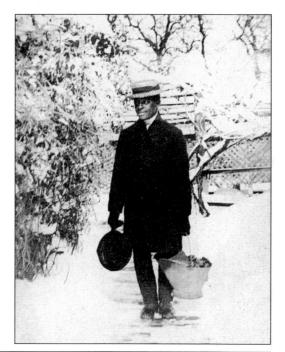

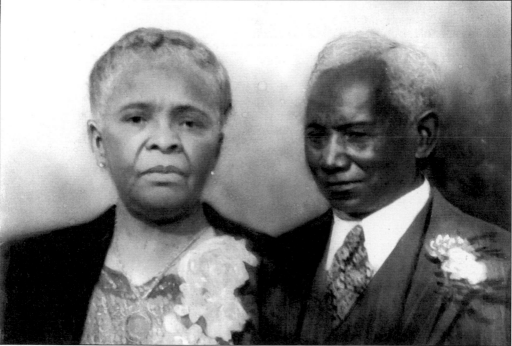

ENTREPRENEUR HOWARD ANTHONY (1872–1953). Howard Anthony, shown here in 1944 with his wife, Emma Davis Anthony, moved to Kenilworth in 1914. He owned and operated several businesses, including a country store, a cesspool maintenance company, and a coal and wood delivery service. Anthony's Star Route won a contract with the post office for the delivery of bulk mail in Union County. He employed many black workers.

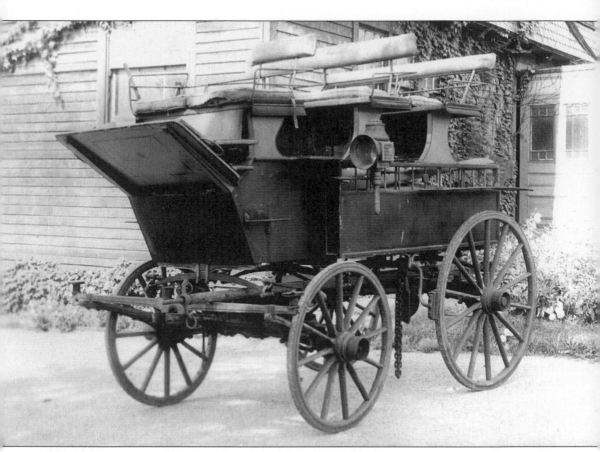

SLAVE CRAFTSMEN–ARTISANS. The contributions of blacks to American craftsmanship began in Colonial times. Slaves worked extensively in the skilled crafts in old Elizabethtown prior to the Civil War and during the ensuing era. Among the many shop owners with slave apprentices were John Ross, Elizabethtown's mayor in 1748, whose apprentice was cobbler Abraham Hendricks, and carriage and coach maker Jonathan Hampton. The contributions of skilled black tanners and cobblers involved in the making of 19th-century carriages or coaches, such as the one pictured above, were rarely acknowledged in history books. The tanner or cobbler learned how to turn animal skins into leather and learned the art of currying, or working oil into leather— a process that left the leather flexible and stronger. This allowed for a wider variety of products, including leather seat coverings (seen above), bodies of carriages made from leather slings called thorough braces, harnesses, and saddles.

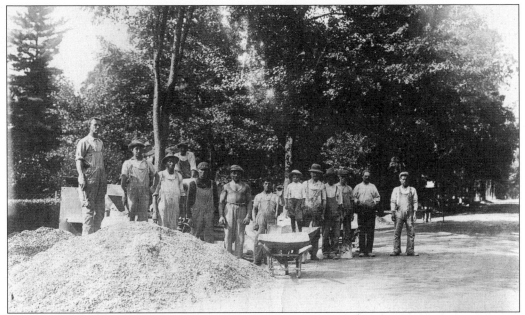

BLACK CONSTRUCTION WORKERS, *C.* 1917. Blacks were skilled in all areas of the building trades and often participated in the construction of public or community buildings in their town, as shown here. The Plainfield City Hall and the Plainfield Post Office are examples of black workmanship on public buildings.

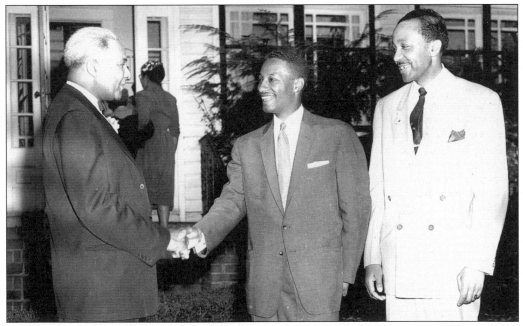

THREE ROSELLE BUSINESSMEN, *C.* 1950s. Many blacks became entrepreneurs in Union County in diverse business ventures. These businessmen are, from left to right, Dr. Charles C. Polk, who had a thriving medical practice for more than 50 years; George G. Woody of the G. G. Woody Funeral Home; and Leonard "Bud" Simmons, owner-operator of a dry cleaning and tailoring business.

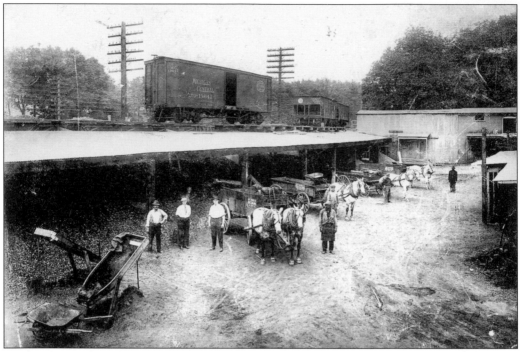

RAILROAD WORKERS, *C.* 1920S. During and after World War II, many new industries started up in Plainfield, creating more job opportunities for black workers. The photograph was taken by Paul Revere Collier (1886–1951).

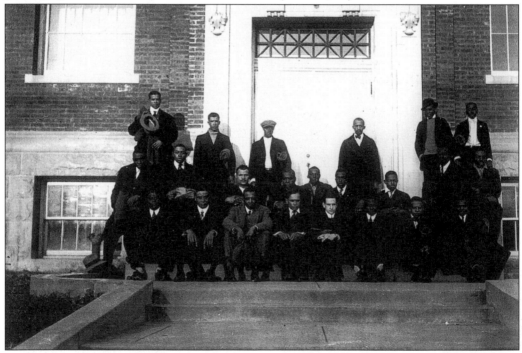

PLAINFIELD CITY HALL WORKERS, LATE 1940S. Several black Plainfield City Hall employees take time to pose for this photograph, taken by Paul Revere Collier.

28

Two

THE BLACK CHURCH

**THE EBENEZER AFRICAN
METHODIST EPISCOPAL CHURCH.**
This illustrated program
cover was designed for the
150th anniversary celebration
(1826–1976) of the Ebenezer
African Methodist Episcopal
Church in Rahway. The
denomination, Methodist in
its basic doctrine and order of
worship, was borne out of
adversity with the white
Methodist Church. Organized
in 1826, Ebenezer is the
third-oldest African Methodist
Episcopal congregation in
northern New Jersey. The
church has occupied its
Rahway Central Avenue
location since 1829. The
present sanctuary was built
in 1949.

THE FIRST PRESBYTERIAN PARISH HOUSE. In 1816, the Elizabethtown Free School Association established a Sunday school for blacks of all ages. The classes were held in the First Presbyterian Parish House. By 1819, eighty blacks were attending the classes. Oliver Nutman was the school's superintendent, with five women and seven men serving as volunteer teachers.

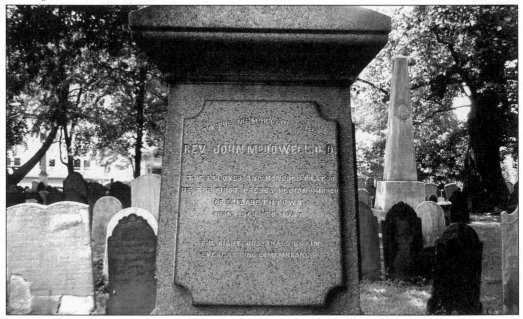

REV. JOHN MCDOWELL, PRESIDENT OF SUNDAY SCHOOL FOR BLACKS, 1816. This gravestone is a tribute to Rev. John McDowell for his many charitable deeds, including serving as president of the Elizabethtown Free School Association and the Sunday School Association. Reverend McDowell came to Elizabethtown in 1804, the same year of the enactment of the Act for the Gradual Emancipation of Slaves.

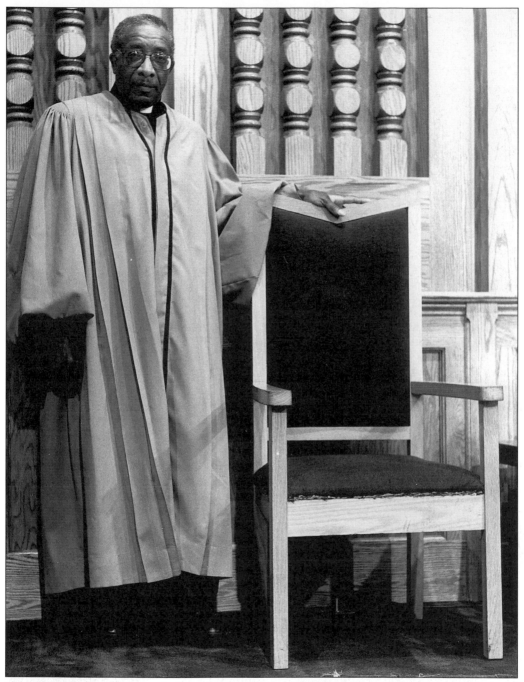

REV. DONALD P. NICHOLS, THE MOUNT OLIVE BAPTIST CHURCH OF PLAINFIELD. Reverend Nichols appears here inside the Mount Olive Baptist Church, the oldest of Plainfield's black congregations. Mount Olive was organized in 1870, after 24 black citizens requested and were granted "letters of dismissal" from the city's predominantly white First Baptist Church. Reverend Nichols has continued the church's long tradition of being in the forefront of the spiritual, economic, and social growth of the black community.

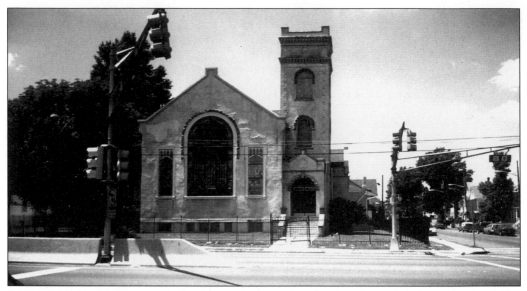

SILOAM HOPE PRESBYTERIAN CHURCH, ELIZABETH. Shown above is the Siloam Hope Presbyterian Church of Elizabeth. Siloam Hope is the third black Presbyterian church to be founded in New Jersey, after those in Newark and Princeton. The Siloam Presbyterian Mission for Blacks evolved out of the Elizabeth Second Presbyterian Church in 1842. The mission was formally elevated to a church in 1873. The church structure pictured above was built *c.* 1895.

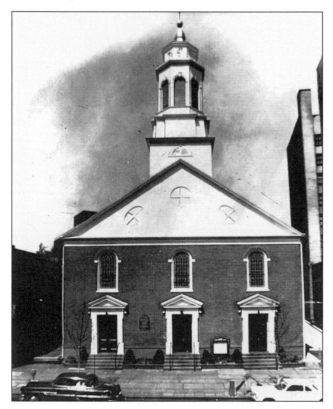

THE SECOND PRESBYTERIAN CHURCH, ELIZABETH, 1821. The Second Presbyterian Church, founded when the congregation of the First Presbyterian Church had outgrown its building, was the birthplace of the Siloam Hope Presbyterian Mission for Blacks. During the 1800s, it was not unusual for white churches to provide "missions" for black worshipers. The Bethel Presbyterian Church of Plainfield evolved out of a small black Presbyterian mission chapel, Hope Mission, which was established in 1884 by the Crescent Avenue Presbyterian Church.

HEARD AFRICAN METHODIST EPISCOPAL CHURCH. Located in Roselle, this African Methodist Episcopal church was founded as Allen Chapel in 1921. In 1924, property was purchased to build a church on East Eighth Avenue. After receiving a financial donation of $500 toward its $850 building contract from Bishop William Henry Heard, D.D., LL.D. (1850–1937), the church was renamed from Allen Chapel to Heard African Methodist Episcopal Church.

FROM SLAVERY TO
THE BISHOPRIC

IN THE
A. M. E. CHURCH

An Autobiography

BY

WILLIAM H. HEARD, D.D., LL.D.

One of the Bishops of the
A. M. E. Church

1928

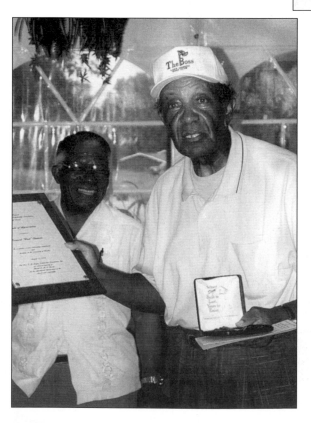

REV. DR. THEODORE R. GOYINS (1925–2004). Reverend Goyins (left), pastor of Heard AME Church for 33 years, poses with Leonard Simmons. Reverend Goyins was a well-respected community leader and activist. He organized a federal credit union and food pantry at his church, an HIV/AIDS commission, and the Help Our Public Education group. He constructed a three-unit affordable housing building, which bears his name.

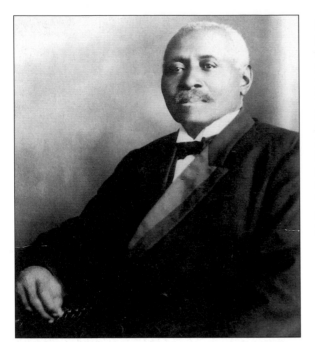

REV. WILLIAM DREW ROBESON (1845–1918). Reverend Robeson was born a plantation slave in North Carolina and, at the age of 15, became a "passenger" on the Underground Railroad. He was pastor of Westfield's St. Luke AME Zion Church from 1907 to 1910. The widowed Reverend Robeson and his youngest child, Paul, moved to Westfield after the white congregation of Princeton's Witherspoon Presbyterian Church had removed him from his 20-year pastorate.

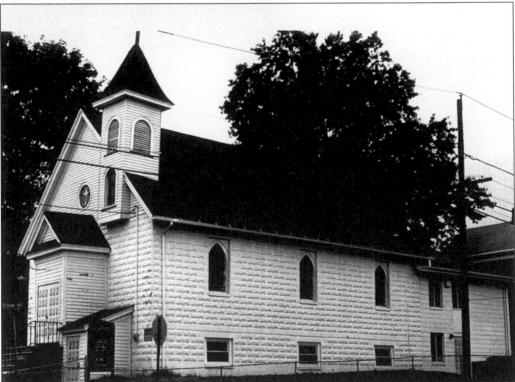

ST. LUKE AFRICAN METHODIST EPISCOPAL ZION CHURCH, WESTFIELD. Under the pastorate and leadership of Rev. William D. Robeson, St. Luke AME Zion Church was erected *c.* 1908 on the above tract of land at the corner of Downer Street and Osborne Avenue in Westfield, where it still stands.

REV. BENJAMIN W. P. ALLEN, PH.D. (1890–1965). Reverend Allen, a graduate of Oberlin College and Drew University, became pastor of the First Baptist Church of Cranford in 1934, serving until 1965. He introduced many innovative programs and activities during his tenure as pastor, including the operation of a lucrative state-chartered credit union with assets over $100,000 and the establishment of a Food and Coal Club, which helped parishioners combat shortages during World War II.

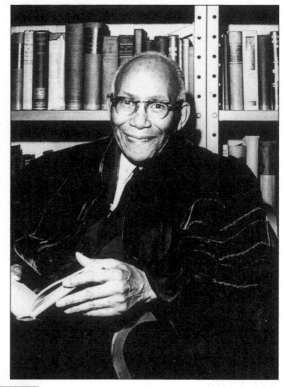

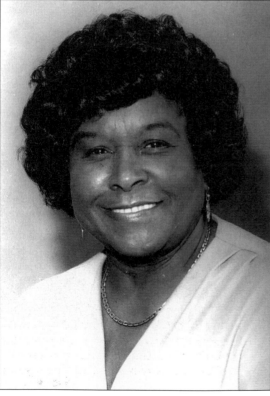

REV. DEBORAH CANNON WOLFE. Reverend Wolfe, born in Cranford in 1916, studied at Union Theological Seminary and was the recipient of 10 honorary degrees. In 1970, after retiring from a successful career as a professor of education at Queens College of the City University of New York, she became the first black woman ordained by the Baptist Church. She served as an associate minister of the First Baptist Church of Cranford, where her father, Rev. David W. Cannon, had ministered from 1911 to 1919.

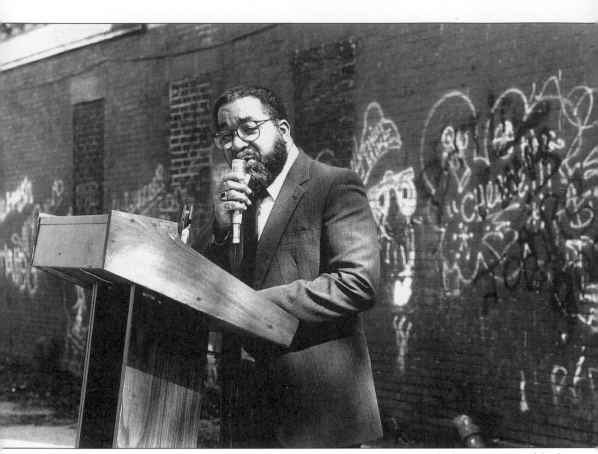

REV. JOSEPH GARLIC (B. 1931). In addition to their ministerial duties, many black ministers continued the tradition of serving as community leaders and activists. In this view, Rev. Joseph Garlic, former director of the Elizabethport Presbyterian Center, delivers an address at the 1991 groundbreaking ceremonies for the renovation of a building to be used as low-income housing. Since 1965, the center, a nonprofit social services agency, has conducted services and programs for low-income families in a section of Elizabeth known as E'port.

MARTHA EASON GOODMAN (1870–1931).
Martha Goodman was one of the founders
of St. Mark's African Methodist Episcopal
Church in Cranford, where she served as
a deaconess. In this *c.* 1890 portrait, she
is tastefully clothed in a two-piece dress
and jacket of silk faille.

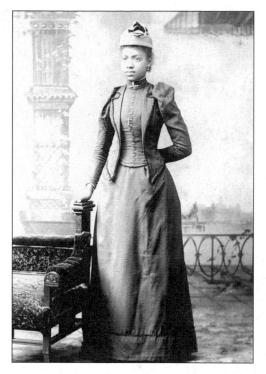

ANA B. MALSON. Although the black
church was not traditionally in favor of
the ordination of women, they still
played active and prominent roles in the
founding and organization of churches
in Union County. Ana B. Malson was
one of the founders of St. Augustine
Episcopal Church in Elizabeth.

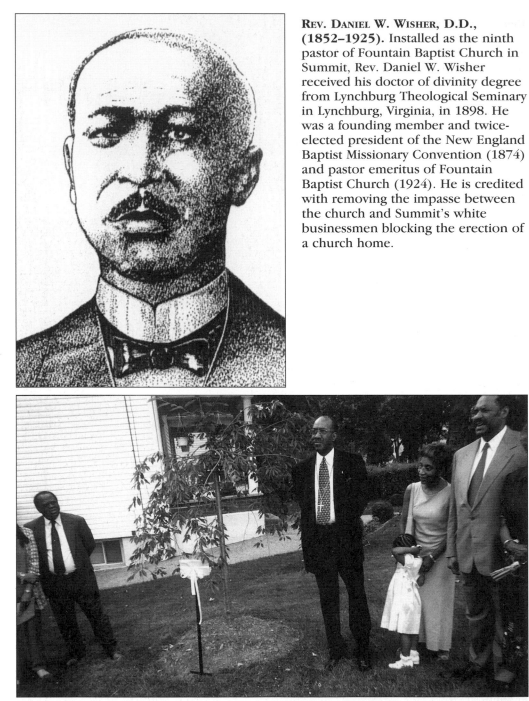

REV. DANIEL W. WISHER, D.D., (1852–1925). Installed as the ninth pastor of Fountain Baptist Church in Summit, Rev. Daniel W. Wisher received his doctor of divinity degree from Lynchburg Theological Seminary in Lynchburg, Virginia, in 1898. He was a founding member and twice-elected president of the New England Baptist Missionary Convention (1874) and pastor emeritus of Fountain Baptist Church (1924). He is credited with removing the impasse between the church and Summit's white businessmen blocking the erection of a church home.

WALLACE CHAPEL, AME ZION CHURCH. Rev. Denison D. Harrield (center), a graduate of Howard University and Union Theological Seminary, has been pastor of Wallace Chapel in Summit since 1989. He has continued the church's tradition of religious leadership and community activism that began in 1925 with the arrival of Rev. Florence Spearing, who retired from the active ministry in 1946. The church purchased its current property and erected its sanctuary, parsonage, and community center in 1928.

KENILWORTH'S FIRST BAPTIST CHURCH, *c.* **1960s.** Kenilworth has a small group of black citizens (184 in the year 2000) who gained early support from city hall for their church-building campaign. Pictured at a 1960s groundbreaking ceremony for the First Baptist Church are, from left to right, Finnard Caldwell, Rev. Russell K. Williams, and Mayor Walter E. Boright. The sanctuary was under construction for years before its completion in 1972. (Courtesy Howard Bailey.)

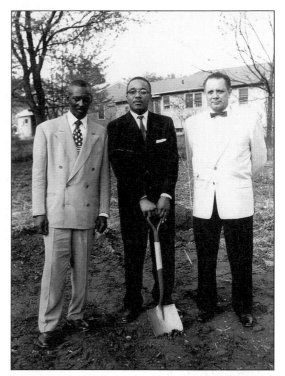

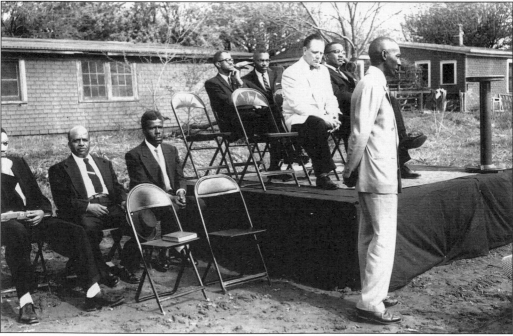

THE FIRST BAPTIST CHURCH OF KENILWORTH. After a group of black residents held a series of nondenominational prayer meetings at various homes from 1898 to 1904, some of the worshipers decided to form their own church, First Baptist. A few of those original worshipers, along with guest clergymen from Somerville, Vauxhall, and Kenilworth, are shown seated as Finnard Caldwell, financial secretary, speaks.

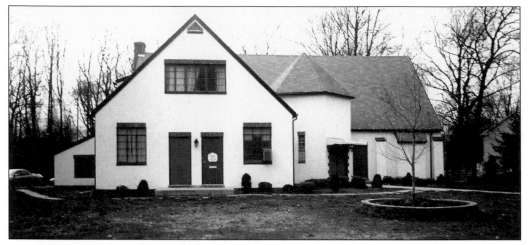

ST. MARK'S EPISCOPAL CHURCH. In the early 1900s, few black Episcopalians existed in Plainfield. St. Mark's Episcopal Church evolved from a "Colored Mission" established by Grace Episcopal Church in 1903. The black communicants severed all ties with Grace in 1914. They officially achieved full diocesan parish status in 1914. The mission constructed and moved into its first church and rectory on East Third Street in June 1922. St. Mark's moved into its second and current home, shown above, in 1978.

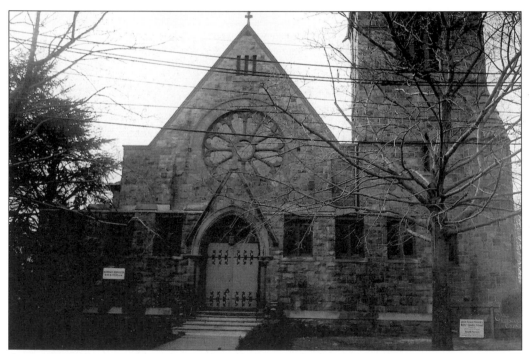

GRACE EPISCOPAL CHURCH. Rev. Edward Vicars Stevenson, a native Canadian, became rector of Grace Episcopal Church in 1902. His first major ministerial initiative involved providing separate services for blacks. Allied with Booker T. Washington's industrial education movement of the early 20th century, Grace established the Industrial School for Colored People in 1904. By 1909, the black mission was gaining autonomy, and the Industrial School initiative was abandoned.

Three

EDUCATION

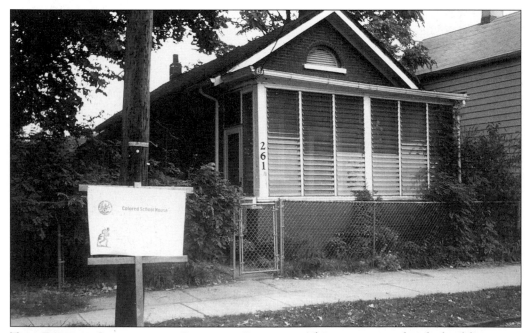

THE RAHWAY SCHOOL FOR COLORED CHILDREN. This one-story brick building was constructed in 1844 as a school for "colored" children through the proceeds of a trust established in 1792 by Isabel Hartshorne Eddy, a philanthropic member of the Society of Friends. The school was absorbed into the public school system in 1872. After the school's closing in 1882, trustees made a $6,000 contribution to the Rahway Public Library. The jalousie window–enclosed porch was not a part of the original structure.

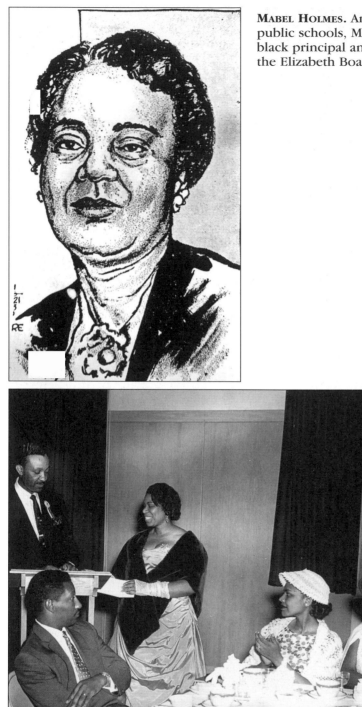

MABEL HOLMES. An educator in the Elizabeth public schools, Mabel Holmes was the first black principal and first black member of the Elizabeth Board of Education.

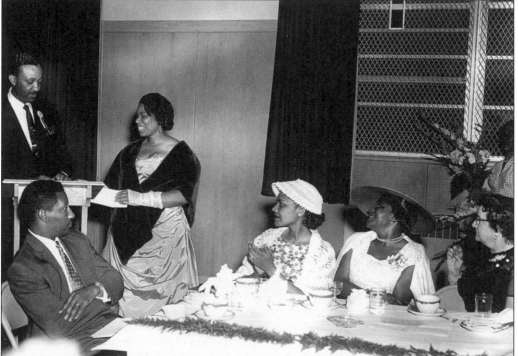

RUTH HEARD MINOR, C. 1950S. Roselle's first black teacher, Ruth Heard Minor (standing), receives an award at a dinner held at the old Winfield Scott Hotel in Elizabeth.

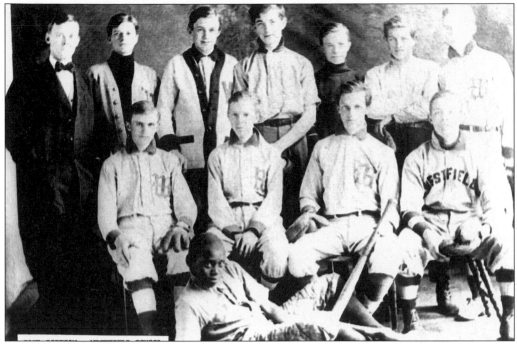

PAUL ROBESON (1898–1976), A STUDENT IN WESTFIELD, 1908. Born in Princeton, Paul Robeson could not attend the public schools of Princeton. At the time, Princeton was strictly a "Jim Crow" city, with black children relegated to a segregated school system that stopped at the eighth grade. After moving the family to Westfield in 1907, Paul's father, Rev. William Drew Robeson, enrolled his son in the integrated public school system in Westfield. Distinguishing himself as an outstanding athlete at a young age, Paul is pictured in 1908 with his Westfield baseball teammates.

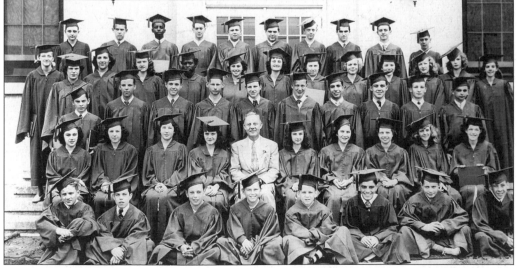

KENILWORTH'S HARDING SCHOOL CLASS OF 1949. Although the Kenilworth public schools were integrated, only two blacks were members of the Harding School class of 1949. In the fourth row, fourth from the left, is Grace Melvin. Howard Bailey Jr. stands third from the left in the last row.

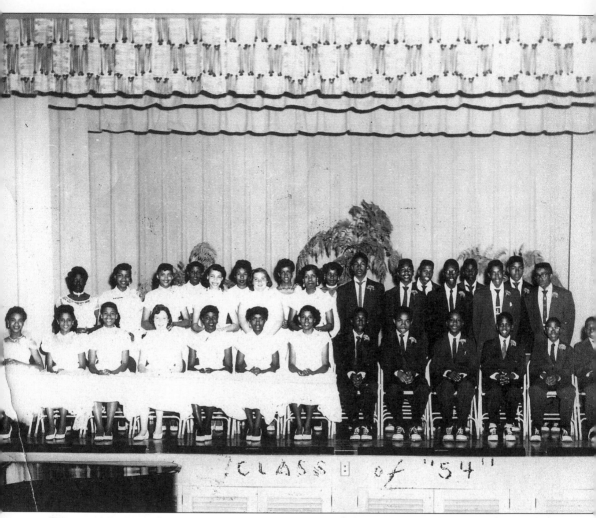

PLAINFIELD'S WASHINGTON SCHOOL CLASS OF 1954. The composition of this all-black Washington School eighth-grade graduation class mirrors New Jersey's practice of de facto segregation in the public schools. In May 1954, the U.S. Supreme Court ruled in the case of Brown v. Board of Education of Topeka that segregation in public education was unconstitutional, declaring that separate was "inherently unequal." In 1947, a group of New Jersey's elected delegates drafted a new state constitution that called for an end to state-supported school segregation. But neither of the two laws has resulted in New Jersey's public schools becoming fully integrated or providing an equal education to all students.

DAYCARE SERVICES AT THE COMMUNITY CENTER, 1980s. From its inception in 1932, the Jerseyland Community Center in Scotch Plains offered after-school and daycare services to neighborhood children.

PLAINFIELD SCHOOLCHILDREN, C. 1965. These elementary school children, residing in Plainfield's predominantly black West End community, pose for a class photograph.

THE PLAINFIELD HEAD START CENTER.
Well received in the community, the
Plainfield Head Start Program continues
to offer all children equal access to early
educational experiences. Pictured here
is the newest of the six Plainfield-based
Head Start Program centers.

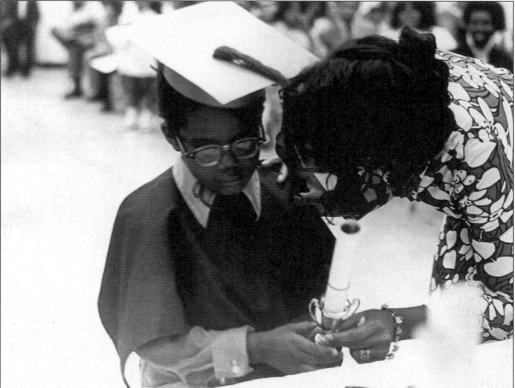

A PLAINFIELD HEAD START GRADUATE, 1971. Trevor L. Weston, dressed in his cap and
gown, receives his graduation diploma from teacher Beulah Womack. Trevor Weston
would continue on to earn his bachelor's degree from Tufts University and his master's
and doctorate degrees from the University of California at Berkeley (see page 69).

DR. CHARLES CARRINGTON POLK (1892–1990). In 1909, Polk became the first graduate of the all-black Lawnside School, located in South Jersey's Lawnside, the first incorporated black township in New Jersey. A 1921 graduate of Howard University Medical School, Polk, along with his wife, moved to Roselle in 1924, where he maintained a general practice for 52 years. He won many awards for his outstanding contributions to the medical profession and the Union County community (see page 123).

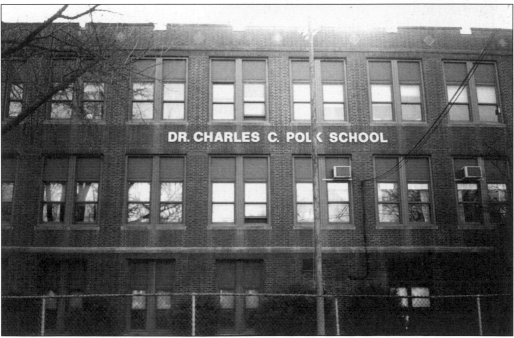

THE DR. CHARLES C. POLK SCHOOL. Polk provided free physicals to Roselle student athletes, shared his extensive collection of books by and about blacks with students, and continually stressed the importance of education. This Roselle elementary school was renamed in his honor in 1992.

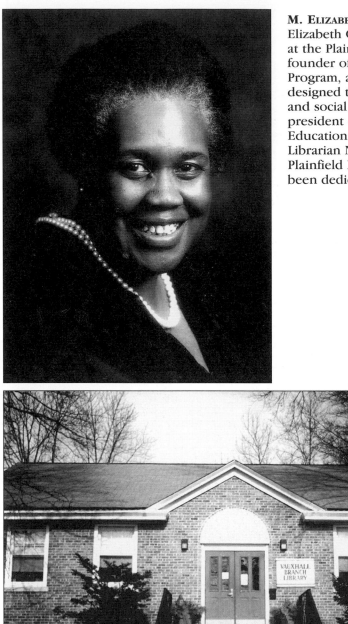

M. ELIZABETH CHITTY (B. 1928).
Elizabeth Chitty is a former librarian at the Plainfield Public Library and founder of the Plainfield Reading Program, a volunteer project designed to develop students' reading and social skills. She served as president of the Plainfield Board of Education and founder of the Black Librarian Network of New Jersey. The Plainfield High School Library has been dedicated in Chitty's name.

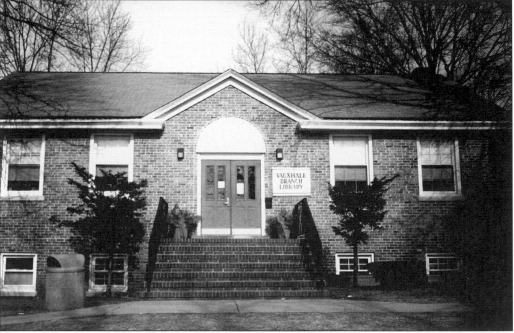

THE VAUXHALL BRANCH OF THE UNION TOWNSHIP PUBLIC LIBRARY. During the era of segregation, small branches of main public libraries were often built in black neighborhoods. Pictured here is the Vauxhall branch of the main Union Township Public Library.

Four

CULTURE AND HERITAGE

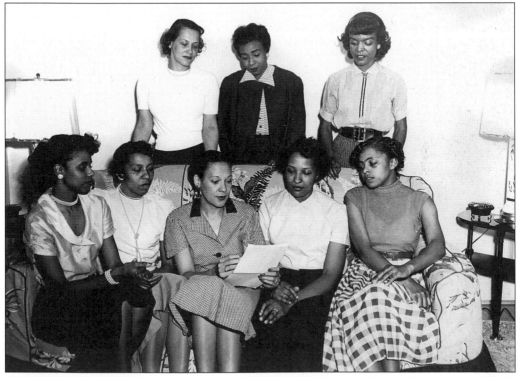

THE MOORLAND BRANCH OF THE COLORED YMCA OF PLAINFIELD. Here, the Semper Fidelis Service Club of the Moorland branch of the Colored YMCA is pictured at a planning meeting in the 1950s. Margaret Patterson (standing, far right) worked as a program aid for the organization.

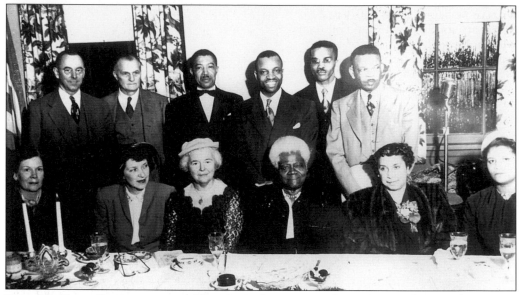

MARY MCCLEOD BETHUNE AT THE WESTFIELD COMMUNITY CENTER, C. 1950S. In the 1950s, Mary McCleod Bethune (1875–1955) was one of the many esteemed guest speakers at the Westfield Community Center's banquets. An activist and educator, she was the founder and president of the National Council of Negro Women and Bethune Cookman College in Daytona Beach, Florida. In 1934, Pres. Franklin D. Roosevelt named her head of the Negro Division of the National Youth Administration.

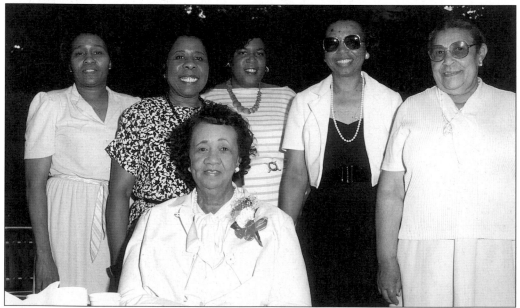

DOROTHY I. HEIGHT (B. 1912), 1989. Dorothy I. Height (seated), president of the National Council of Negro Women (1947) and former national president of Delta Sigma Theta Sorority (1947–1956), relaxes with members of the New Jersey State Council at the Plainfield home of state coordinator Lillian V. Hughes. Standing from left to right are Josie Pigford, state convener Evelyn S. Field, Beverly Y. Murdock, Doris Mack, and Lydia Emanuel. While in town, Height gave a presentation at Calvary Baptist Church.

WILLIAM M. ASHBY (1889–1991).
Noted author and civil rights pioneer
William M. Ashby formed the Urban
League of Union County and served
as its director from 1944 to 1953.

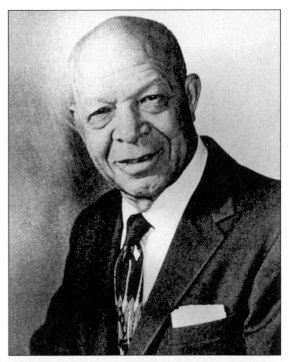

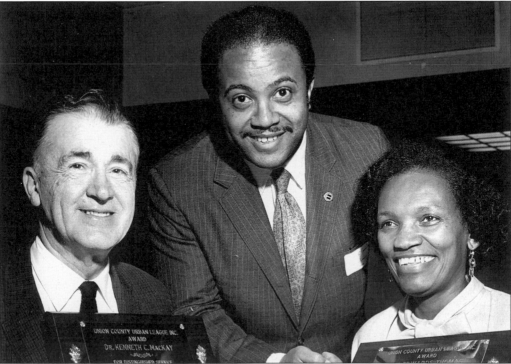

THE URBAN LEAGUE OF UNION COUNTY. Leroy R. Coles Jr., former president of the Urban
League of Union County (center), poses with Dr. Kenneth MacKay and Elizabeth native
Nida Edwards Thomas, one of the league's first staff members. Thomas (b. 1914)
developed New Jersey's first affirmative action plan for education (see page 101).

MILLS BARNES (1898–2001).
In 1920, Plainfield High School graduate Mills Barnes (class of 1917), along with three others, organized the Plainfield Negro History Club to help fight segregation and other forms of racial discrimination. He majored in pharmacy at Union University in Albany, New York, and worked for the Standard Oil Company for 37 years. A black-history buff, Barnes organized the Plainfield chapter of the NAACP.

EVA BRIDGES (B. 1923).
Historian and Rahway native Eva Bridges, founder of the Rahway-based Afro American Research Library and Museum at Bridges Book Center, is surrounded by her collection of black art and artifacts as she poses with an illustrated portrait of Dr. Martin Luther King Jr. A graduate of Newark State College, she opened Bridges Book Store in 1970, after retiring from a teaching career. She later expanded the operation to include a research library and museum.

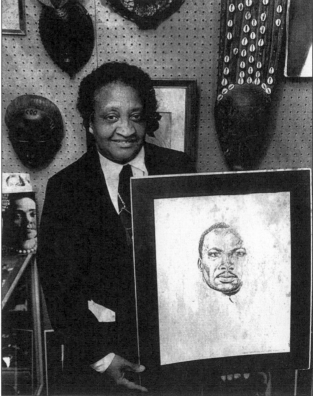

THE COLLEGE WOMEN'S CLUB, *c.* **1940s.** The founding members of the College Women's Club of Union County include, from left to right, Olive Polk, Ellen Hareston, Grace Randolph Woody, Pauline Sims Puryear, Agnes Durrah, and Dr. Myra Smith Kearse. Kearse, the first black physician in the Vauxhall section of Union Township, practiced medicine from her home.

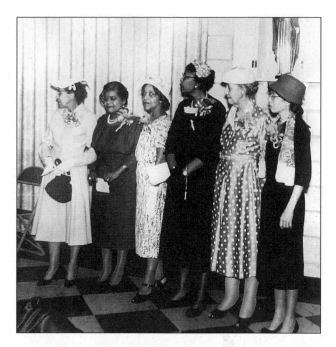

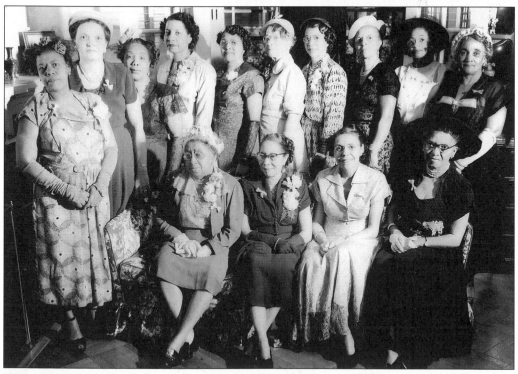

JUST-A-MERE LITERARY CLUB OF ROSELLE. In 1920, the Just-a-Mere Literary Club of Roselle was established by a group of professional black women to study and discuss literature. Group members are, from left to right, as follows: (first row) ? Lewis (cofounder), B. Lester, O. Polk, and L. Vendell; (second row) M. Wilmore, M. Pulley, M. Hebbons, E. Lester, E. Wiggins, G. Smith, P. Tappan, E. Henderson, E. Pulley, and H. Bell (cofounder).

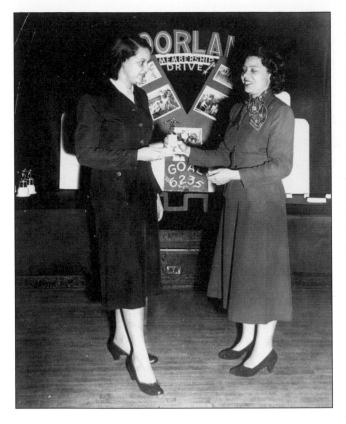

PLAINFIELD'S MOORLAND BRANCH OF THE YMCA. Thelma Lambert (right) presents a trophy to her sister Margaret Lambert at a 1947 membership drive organized by the "colored" East Fifth Street Moorland branch of the YMCA. This branch was borne out of the national organization during the era of segregation. Senior secretary Rev. Jesse Moorland spent 25 years, from 1891 to 1923, developing the Colored Men's Department of the YMCA into a national institution for black cultural self-improvement.

Objective For 1947

This year, 1947, our program for youth and adults will be greater than any other year at Moorland. This calls for a great increase in our financial obligations. With this in view, the financial goal for 1947's Membership Campaign is set at 600 members and $2,000 cash. We invite you to join during our membership drive which takes place from March 15, 1947, to April 1, 1947.

A Captain of one of the teams will call on you during the Membership Drive. We will be grateful if you will give our co-workers a few minutes of your time and your Membership.

"Y" LEADERS

Working Together For The "Y" In Our Community

MEMBERSHIP CAMPAIGN

ORGANIZATION

Mr. Spencer Logan
General Chairman

Mr. Ernest Taylor
Assistant General Chairman

Dr. A. A. Reid
Assistant General Chairman - Publicity

Mrs. Louise Mason
Assistant General Chairman

Rev. A. R. Brent
Chairman of Church Publicity

Mr. R. Ponder
Divisional Leader

Mr. Aubrey Lambert
Divisional Leader

Mr. Cyril Lambert
Chairman, Committee of Management

Mrs. Antoinette Whetstone
Secretary, Membership Drive

W. E. Hogan
Executive Secretary

YMCA

A BETTER BOY

•

A BETTER CITIZEN

•

A BETTER COMMUNITY

•

A BETTER WORLD

THE YMCA'S MEMBERSHIP LEAFLET. Shown is a portion of a leaflet designed by Plainfield's Moorland branch of the YMCA to promote its 1947 membership drive throughout the black community.

**DR. ROBERT H. THOMPSON AND VIVIAN
BROCK.** Westfield Center Association
members Robert H. Thompson, D.D.S.,
and Vivian Brock (first president)
spearheaded the movement to establish
the Westfield Community Center and its
membership in the United Fund after
the National Youth Administration had
given up its sponsorship. The center
began as a toy-lending library in 1938
under the National Youth
Administration. Now in its 65th year,
the center's mission and programs
have expanded and now include an
expansive youth educational and
cultural affairs component.

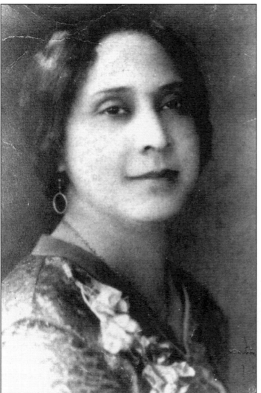

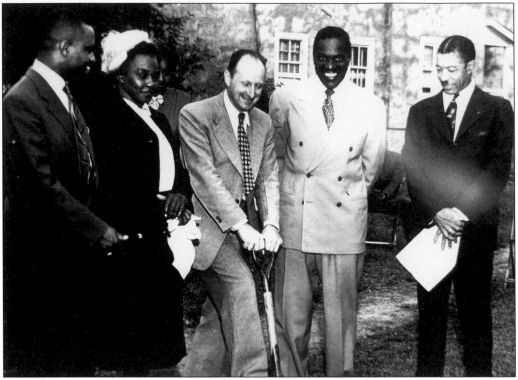

THE WESTFIELD COMMUNITY CENTER'S GROUNDBREAKING CEREMONY. Westfield physician and board of trustees member Dr. Howard Brock is pictured fourth from the left at the *c.* 1948 groundbreaking ceremony for the new Westfield Community Center, located at 558 West Broad Street.

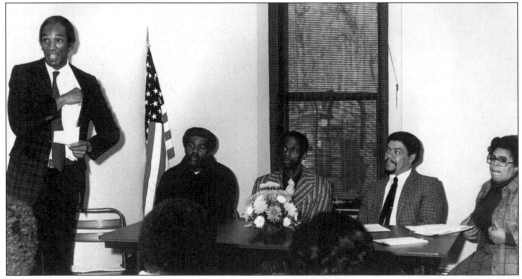

JERSEYLAND PARK IS RENOVATED. Jerseyland community native James McCauley (standing) speaks to a group of members and supporters at the opening celebration of two newly renovated buildings in 1982. Elizabeth Grobes, daughter of the late founder and president, cut the ribbon.

ELIZABETH GROBES (1876–1978). This holiday greeting card was created by the Jerseyland Park Community Center in honor of its founder, Elizabeth Grobes. The neighborhood civic and recreational center was founded on its current Scotch Plains site in 1932. Originally the John Locey farmhouse (1740–1800), the property was purchased from the Citizens Building and Loan Association of Elizabeth for $4,500. The center closed in 1957 and reopened in 1982.

You'll always be the star on my tree.

Founder JPCC
Mrs. Elizabeth D. Grobes
June 27, 1876 to April 10, 1978

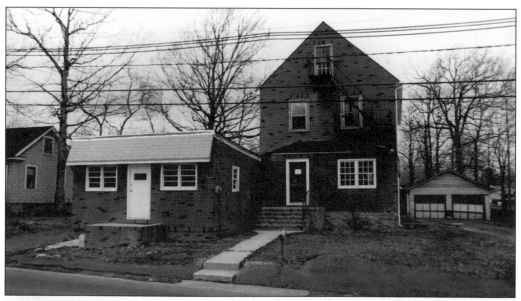

THE RENOVATED JERSEYLAND PARK COMMUNITY CENTER. In 1980, Jerseyland community leaders obtained a Community Development Grant for the restoration and renovation of the two buildings located on the center's nine and three-quarter acres of wooded parkland adjacent to Jerusalem Road in Scotch Plains. The renovated buildings are pictured here.

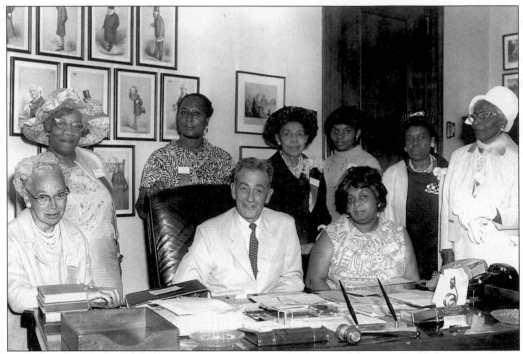

THE NEW JERSEY STATE FEDERATION OF COLORED WOMEN'S CLUBS, *C.* 1950s. Officers of the Union County chapter pay a visit to Sen. Clifford P. Case in his Washington, D.C., office. Black women joined forces in their own organizations to improve social, educational, and working conditions in their communities.

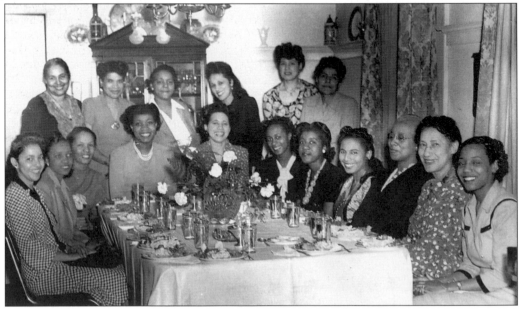

ALPHA KAPPA ALPHA, BETA ALPHA OMEGA CHAPTER, *C.* 1954. Members of the Beta Alpha Omega chapter of Alpha Kappa Alpha, a national public service sorority, meet and dine at the Roselle home of member Olive Bond Polk (standing, far right). This chapter, the first to be established in New Jersey, included women from across the state.

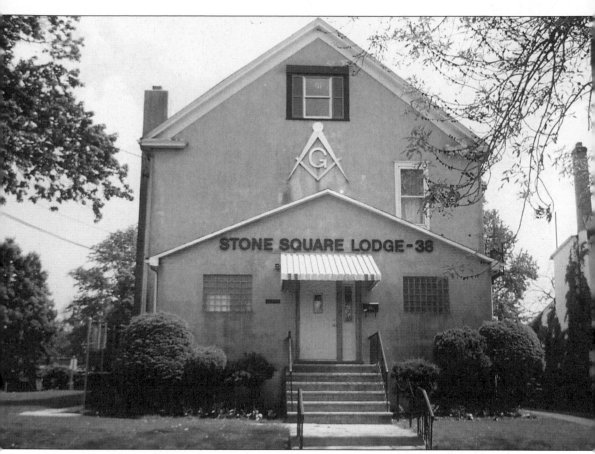

THE STONE SQUARE LODGE, NO. 38, FREE AND ACCEPTED MASONS. This Plainfield-based fraternal organization was chartered in 1887 as an affiliate of the national Prince Hall Masonic fraternity. Prince Hall (1748–1807) founded the first African Masonic Lodge of Boston in 1784 after he was refused entry into the English Masonic organization. The building shown here was erected in 1912 by a select group of skilled black masons who were active members of the lodge during that period. The masons, who received praise for their craftsmanship, took pride in the fact that they were able to build this structure without the help of white workers. The stone structure, located on its original site on St. Mary's Avenue in Plainfield, continues to serve as the organization's headquarters and as a meeting place and social outlet for other community groups. Prince Hall Affiliated Lodges are also located in other Union County towns, including Elizabeth, Roselle, Rahway, and Scotch Plains.

THE MOHAWK LODGE OF THE ELKS, PLAINFIELD. In 1944, members of the Plainfield Mohawk Lodge held a testimonial dinner in honor of their lodge brother Joseph Judkins, the 1927 founder of Judkins Funeral Home. After the Civil War, this lodge and other fraternal organizations became important sites of black male community life.

BLACK WOMEN AND FRATERNAL ORGANIZATIONS. Formally dressed hostesses pose for a photograph at Joseph Judkins's 1944 testimonial dinner. Fraternal organizations stood at the center of life for black women and provided them with public roles alongside their male counterparts. This group served as hostesses for a testimonial dinner organized by the Plainfield Mohawk Lodge of the Elks.

DELTA SIGMA THETA SORORITY, CENTRAL JERSEY ALUMNAE CHAPTER. The Central Jersey Alumnae chapter of Delta Sigma Theta, an international black public service sorority, was chartered on November 1975 in Plainfield. The charter members are, from left to right, as follows: (first row) P. Merle Wade, Arneida Lee (first president), and Patricia Garrison; (second row) Marietta Blow, Emma Johnson, and Victoria Brown; (third row) Joylette Mills-Ransome and Emma Warren.

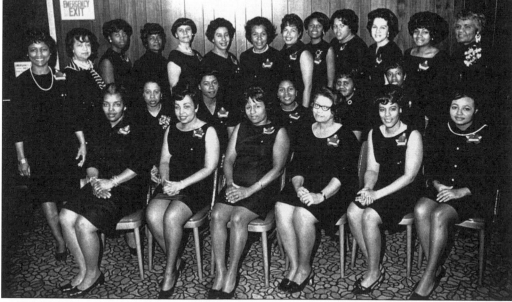

ALPHA KAPPA ALPHA SORORITY, THETA PHI OMEGA CHAPTER. Pictured in 1968 are the charter members of the Plainfield Phi Omega chapter of Alpha Kappa Alpha, the first chapter established in Union County. An international public service sorority, Alpha Kappa Alpha was the first U.S. Greek-letter organization established by black American college women.

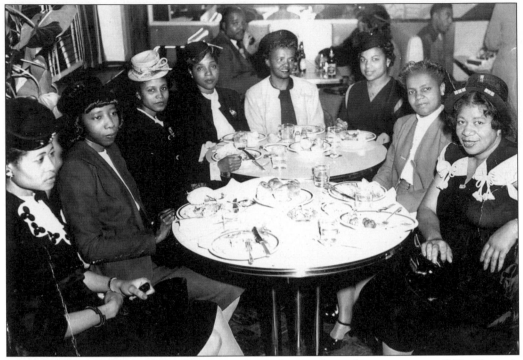

KENILWORTH'S LADIES' GROUP. Beginning in the early 1940s, a group of Kenilworth ladies would get dressed up and travel to Harlem, New York, for dinner and other social and cultural activities. The trip became an annual affair. Seated, from left to right, are Benna-Mae Ausley, Joyce Bowers, Equilla Young, Zorabell McKinnie, Lavinia Anthony, Virginia Tucker, Iola Bailey, and Flora King.

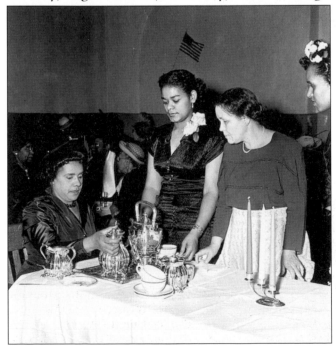

TEA TIME, c. 1940s. Pictured at a 1940s tea party at Plainfield's Moorland branch of the YWCA are, from left to right, Sarah Judkins (pouring), Lillian McGowan, ? Redd, and Ruth Ganey.

THE BLACK CULTURAL AND HISTORICAL SOCIETY. This program booklet was designed for the 15th Annual Frederick Douglass Awards Dinner Dance of the Black Cultural and Historical Society of Union County. Organized in 1976, the society honored blacks residing or working in the county who best exemplified the legacy of black abolitionist Frederick Douglass (1817–1895). The society has been inactive for several years.

BLACK CULTURAL & HISTORICAL SOCIETY OF UNION COUNTY

Presents

**THE FIFTEENTH ANNUAL
FREDERICK DOUGLASS AWARDS DINNER DANCE**

Honoring

Freeholder
GERALD B. GREEN

February 16, 1991
THE WESTWOOD
483 North Avenue
Garwood, New Jersey

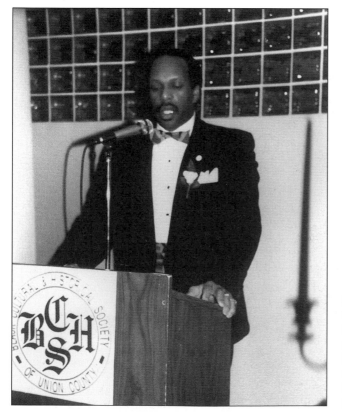

SIDDEEQ W. EL-AMIN. A two-term president of the Black Cultural and Historical Society of Union County, Siddeeq W. El-Amin speaks at the society's awards dinner honoring former Union County freeholder Gerald B. Green.

63

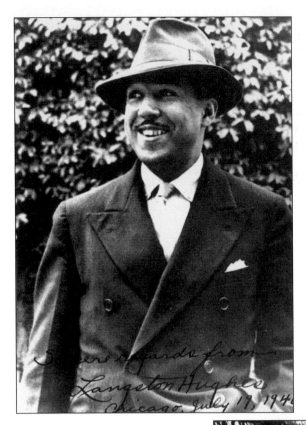

LANGSTON HUGHES (1902–1967).
Considered the most prolific writer of the Harlem Renaissance, Langston Hughes was a poet, playwright, lyricist, anthologist, autobiographer, and fiction writer. In the fall of 1928, at the age of 26, Hughes came to Westfield, where he stayed until 1931. In 1930, while residing on Downer Street, he completed his first novel, *Not Without Laughter.* The novel won him the Harmon Gold Award for Literature.

THE HOME AT 514 DOWNER STREET, WESTFIELD. Langston Hughes was a boarder in the James V. Peoples family residence at 514 Downer Street in Westfield from 1928 to 1931. The house was across an open lot from St. Luke AME Church, where Paul Robeson's father had served years before. The neighborhood was comprised of a small group of middle-class black families. This photograph shows the house as it is today.

**ZORA NEALE HURSTON
(1891–1960).** Writer and
folklorist Zora Neale Hurston,
a 1928 graduate of Barnard
College, was the most prolific
black female writer in the
country throughout the 1950s.
In 1929, Hurston followed her
friend Langston Hughes to
Westfield and moved into a
nearby residence. A feud
erupted between the two
while they were collaborating
on the play *Mule Bone.*
Hurston abruptly left Westfield
in 1930 and later denied
Hughes's coauthorship.

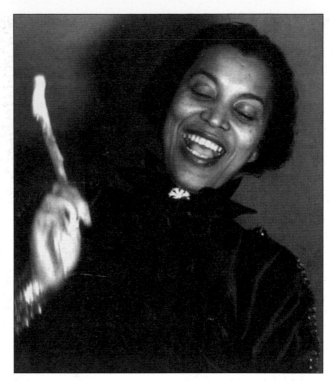

MULE BONE
A COMEDY OF NEGRO LIFE

LANGSTON HUGHES AND
ZORA NEALE HURSTON

Edited with Introductions by George Houston Bass
and Henry Louis Gates, Jr.
and the complete story of the *Mule Bone* Controversy

Harper Perennial
A Division of HarperCollins Publishers

MULE BONE. In 1931, Langston
Hughes discovered that Zora Neale
Hurston had copyrighted *Mule Bone*
exclusively in her name and
submitted it for production to their
mutual friend Carl Van Vechten. This
dispute, which was never resolved in
Hurston's and Hughes' lifetime, led
to a 60-year delay in the publication
and performance of the play.
This page, taken from the 1990
Mule Bone paperback edition, shows
joint authorship.

INDIRA BAILEY. A Plainfield native, painter and art teacher Indira Bailey graduated from the Pratt Institute in New York City with a degree in communications design. The style and subject matters of artists Ernie Barnes and Norman Rockwell inspired her work. Bailey received a 2004 Fulbright Scholarship for summer travel and study of post-apartheid and art education in South Africa.

THREE SPIRITUALS FROM EARTH TO HEAVEN. Allan Rohan Crite, born in Plainfield in 1910, is a renowned painter and printmaker. A devout Episcopalian, he created this pen-and-ink drawing, published in *Three Spirituals from Earth to Heaven* (1948). The volume consists of pictorial interpretations of three Negro spirituals of a contemplative nature: "Nobody Knows the Trouble I See," "Swing Low, Sweet Chariot," and "Heaven." Opera singer Roland Hayes (1887–1976) wrote the book's introduction.

Nobody knows the trouble I see

ALONZO ADAMS (B. 1961). Plainfield artist Alonzo Adams earned his bachelor of fine arts degree from Rutgers University in 1984. He attended the duCret School of Art in 1985 and the Pennsylvania Academy of Art in 1989. In 1991, he earned his master of fine arts from the University of Pennsylvania with a Camille Cosby Fellowship. His work has been inspired by Charles White, Henry O. Tanner, John Singer Sargent, and Rembrandt. Adams and his wife, Cyndie, own the Sienna Visions Fine Arts Gallery in Plainfield.

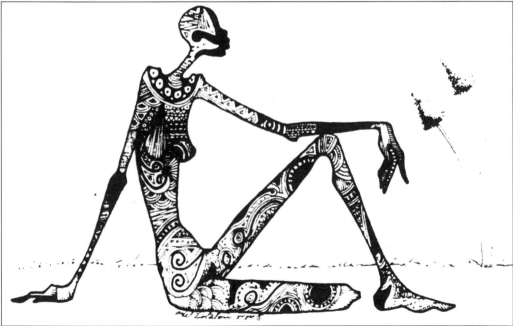

A 1984 PEN-AND-INK DRAWING BY MELVIN HOLSTON. Multimedia artist Melvin Holston studied at the Fashion Institute of Technology in New York City and Jersey City State College, where he graduated with a bachelor of arts in art education. Holston's unusual pen-and-ink drawings of elegant, elongated African figures are reminiscent of scarification markings identifying proud cultures and customs in Africa.

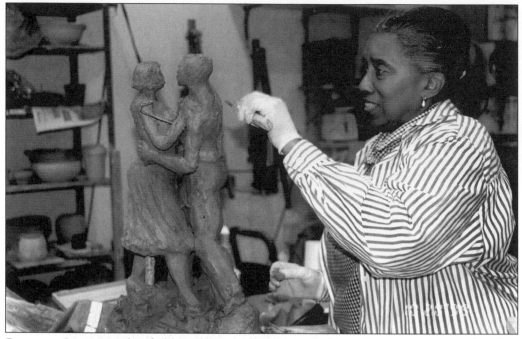

DOLORES STEWART. Plainfield sculptor and painter Dolores Stewart is pictured in her home studio. Initially interested in portrait painting, Stewart switched to sculpture while enrolled at the New Jersey Center for the Visual Arts in Summit. Stewart has studied continuously at the duCret School of the Arts in Plainfield and at the New School in New York City. She has shown her work at the Newark, Morristown, and Montclair Art Museums.

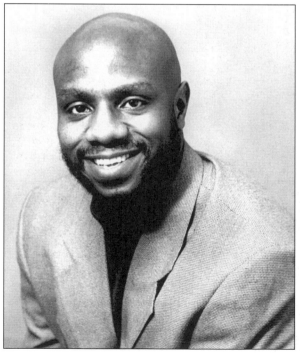

JOMO KENYATTA. Plainfield photographer Jomo Kenyatta studied photography at Northern Virginia Community College in Arlington. He mentored under Tom Jinks, a professional freelance and wedding photographer. Kenyatta's images have placed in many competitions. He is currently working on a photo essay entitled "The Carribean Unseen," designed to capture life as it "really is" in Jamaica, Dominica, and other areas of the Caribbean.

EDWARD PIERSON. Bass-baritone Edward Pierson, a longtime resident of Elizabeth, began his operatic career as "Don Carlo" with the Chicago Lyric Opera in 1964. In 1966, he made his debut at the New York City Opera in *Don Rodrigo.* Pierson has been under contract at the Lincoln Center House since 1966. He has sung such roles as Creon in *Oedipus Rex* and Bartolo in *The Barber of Seville.* He was the leading baritone in the American premiere of Britten's *Burning Fiery Furnace.*

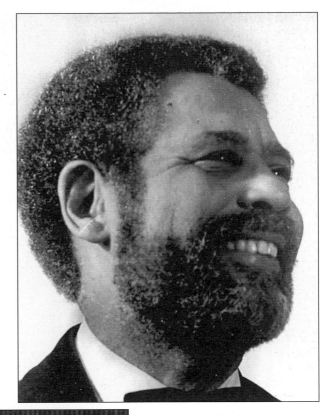

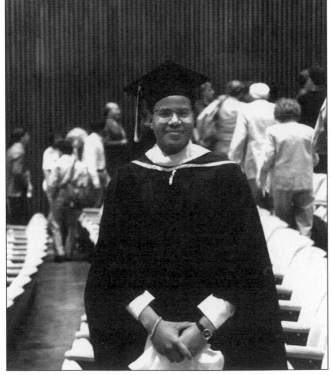

TREVOR L. WESTON. Native to Plainfield, Trevor L. Weston sang with the renowned St. Thomas Church Choir in New York and performed at Carnegie Hall as a choirboy in 1979. An assistant professor of music at the College of Charleston in South Carolina, Weston earned his bachelor's degree at Tuft's University and his master's and doctorate degrees at the University of California at Berkeley. In 2004, he returned to Carnegie Hall to perform his musical composition "Vision's of Glory."

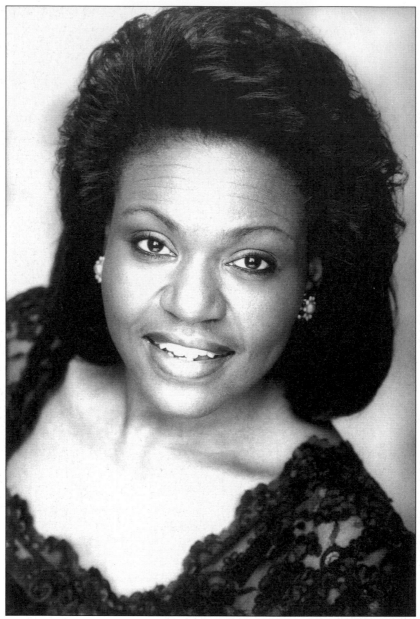

OPERA SINGER LISA DALTIRUS. Soprano Lisa Daltirus, a graduate of Plainfield High School and the Westminster Choir College in Princeton, received rave reviews in the *New York Times,* the *Philadelphia Inquirer,* and *Opera News* for her 2002–2003 season debut performances in the title role in *Tosca* with the New York Grand Opera and Opera Delaware. The season ended when she replaced Carol Vanes at the Aspen Music Festival. She returned the summer of 2004 to perform the *Verdi Requiem* under David Zinman. Daltirus opens the 2004–2005 season as Tosca with the El Paso Opera, followed by the title role in *Aida* with Willy Anthony Waters in Hartford and *Tosca* with the Michigan Opera Theatre in Detroit, and her Amsterdam debut as Lia in Debussy's *L'enfant Prodigue.* She recently gained the attention of Placido Domingo and will cover Maria Guleghina with the Washington Opera in 2005 for *I Vespri Siciliani.*

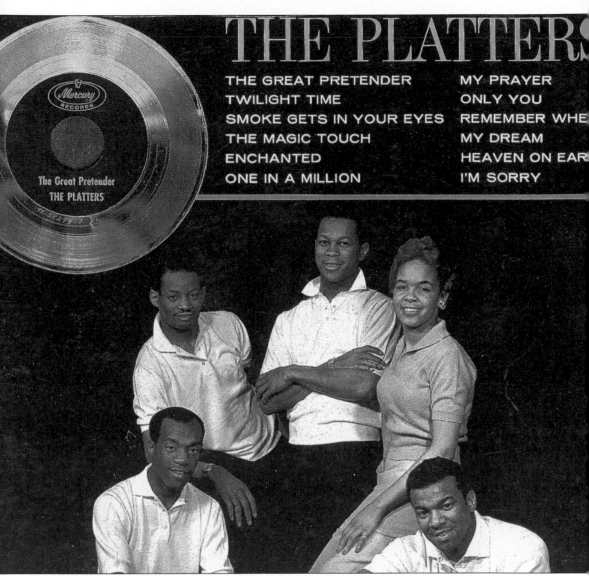

THE PLATTERS

THE GREAT PRETENDER MY PRAYER
TWILIGHT TIME ONLY YOU
SMOKE GETS IN YOUR EYES REMEMBER WHE
THE MAGIC TOUCH MY DREAM
ENCHANTED HEAVEN ON EAR
ONE IN A MILLION I'M SORRY

The Great Pretender
THE PLATTERS

TONY WILLIAMS, LEAD SINGER OF THE PLATTERS. After graduating from Roselle High School in the late 1940s, Tony Williams (1928–1992) received voice training by singing in local gospel groups before moving to Los Angeles. In 1953, Williams (standing in the center) united with bass Herb Reed, tenor David Lynch, and baritone Alex Hodge to form the original Platters doo-wop group. With Williams as the lead vocalist from 1955 to 1960, the Platters became one of the top vocal groups of the 1950s. They were inducted into the Rock and Roll Hall of Fame in 1990. The album shown here, issued on a 1950s Mercury record label, contains 12 of the Platters' greatest songs from the 1950s. "The Great Pretender" was very popular in 1956 and the No. 1 pop song for the Platters, the first black act of the rock era to reach No. 1 on the pop chart. After their initial success, the group went on to record 33 more pop hits on the Mercury label by 1962.

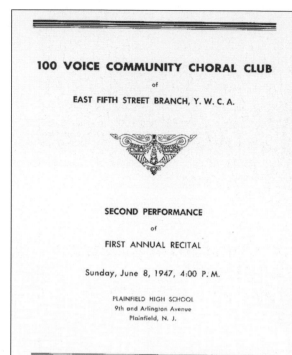

100 VOICE COMMUNITY CHORAL CLUB

of

EAST FIFTH STREET BRANCH, Y. W. C. A.

SECOND PERFORMANCE

of

FIRST ANNUAL RECITAL

Sunday, June 8, 1947, 4:00 P.M.

PLAINFIELD HIGH SCHOOL
9th and Arlington Avenue
Plainfield, N. J.

THE 100 VOICE COMMUNITY CHORAL CLUB. Plainfield's East Fifth Street Moorland branch of the YWCA presented the 100 Voice Community Choral Club at a recital on June 8, 1947. The choral group sang spirituals including "We Are Climbing Jacob's Ladder," "Ain't That Good News," and "Swing Low, Sweet Chariot."

THE KEAN-BROWN CENTER STAGE. The inaugural season of the Grant Avenue Community Center's performance series opened in 1987 with "Creative Spirit at Center Stage." The theater was named in honor of former governor Thomas H. Kean and New Jersey assemblyman Willie B. Brown. In 1991, the Kean-Brown Center Stage and the National Black Touring Circuit presented *Queen of the Blues,* which featured singer Theresa Hightower as Dinah Washington. The center closed its doors in the mid-1990s.

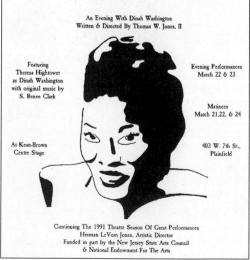

Grant Avenue Community Center &
National Black Touring Circuit Present
Jomandi Productions'

QUEEN OF THE BLUES

An Evening With Dinah Washington
Written & Directed By Thomas W. Jones, II

Featuring
Theresa Hightower
as Dinah Washington
with original music by
S. Renee Clark

Evening Performances
March 22 & 23

Matinees
March 21,22, & 24

At Kean-Brown
Centre Stage

403 W. 7th St.,
Plainfield

Continuing The 1991 Theatre Season Of Great Performances
Herman LeVern Jones, Artistic Director
Funded in part by the New Jersey State Arts Council
& National Endowment For The Arts

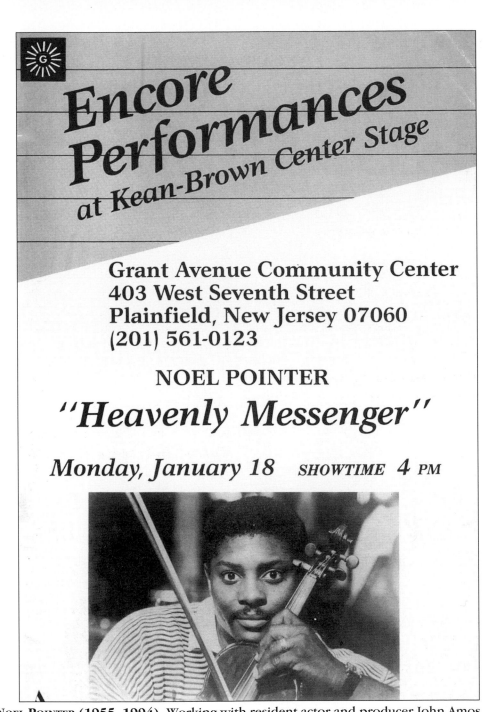

Encore Performances
at Kean-Brown Center Stage

**Grant Avenue Community Center
403 West Seventh Street
Plainfield, New Jersey 07060
(201) 561-0123**

NOEL POINTER
"Heavenly Messenger"

Monday, January 18 SHOWTIME **4** PM

NOEL POINTER (1955–1994). Working with resident actor and producer John Amos, the late jazz violinist Noel Pointer opened the 1988 Kean-Brown Center Stage season with his "Heavenly Messenger" concert in celebration of Dr. Martin Luther King Jr.'s birthday. Pointer studied classical violin before signing with Blue Note as a jazz musician in the early 1970s. In 1978, he moved to United Artists, where he recorded his *Hold On* LP, featuring Patti Austin. In 1993, a year before his death, Pointer recorded on Shanachie's *Never Lose Your Heart*.

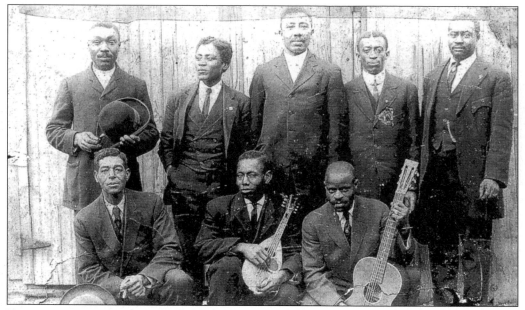

THE SAME OLD BUNCH (TSOB). This vaudeville musical group originated in the early 1900s. Members of the Anthony family, who were residents of Union County, performed with the group. Pictured here are, from left to right, the following: (first row) Elek Wilson, Howard Anthony Sr., and Robert Lindsay; (second row) Elijah Jones, George Anthony, James Anthony, ? Deets, and Donald Skelton.

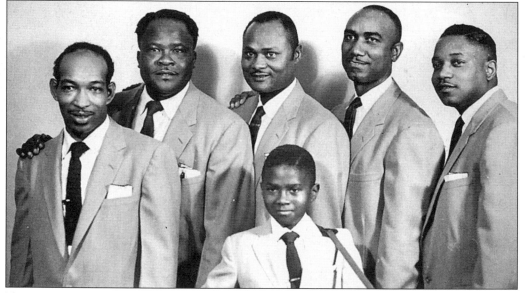

THE CARNATION JUBILEE SINGERS. Clarence Boyce (third from the left) and his son Frankie, playing guitar at age nine, are seen here *c.* 1952 with the family gospel group, the Carnation Jubilee Singers. The family, moving to Plainfield in 1957, performed at weekend gospel concerts in the 1950s. Frankie and his brother Richie began backing up the Parliaments in 1963. They performed and recorded demos under the production of Plainfield barber George Clinton, who in the 1970s masterminded the bands Parliament and Funkadelic (see page 87).

A PIANO RECITAL IN VAUXHALL, 1943. Students perform in a 1943 piano recital at the First Baptist Church of Vauxhall in Union Township. Rosette Norwood Lattimore, standing second from the left in the first row, is a retired elementary school teacher and Plainfield's first "black First Lady." Her younger sister Dolores Norwood Andrews is seated in the front row, fourth from the left.

SALLY PAGE HUGHES. A 1947 graduate of the former Battin High School in Elizabeth, Sally Page Hughes began writing and publishing her poetry in the early 1990s. Among her poetry publications are *New Beginnings* and *E'Port: A Poetic Memoir.* Hughes's musical composition "On the Winning Side" was selected for inclusion on country singer Kate Miller's *Hallelujah* album, produced by Rainbow Records in 1992.

GENEVA "PEPSI" LOUISE CHARLES (1948–2002). Writer, poetess, and community activist Geneva "Pepsi" Louise Charles graduated from Elizabeth's Battin All Girls High School and Boston University. She was a writer and contributing editor for *Essence* and *Elan* magazines. Her poetry, articles, and commentaries appeared in numerous publications, including the *Village Voice, Negro Digest, Black World, Encore,* and the *Boston Phoenix.*

Five

THE MILITARY, LAW ENFORCEMENT, AND JUDICIARY

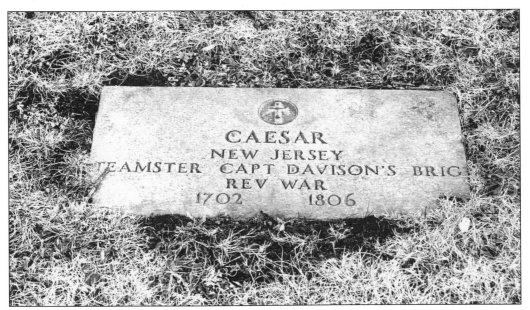

CAESAR (1702–1806), A REVOLUTIONARY WAR VETERAN. Caesar's tombstone, located in Rahway Cemetery, is the only official recording of his service as a teamster in the Revolutionary War. The number of runaway slaves increased greatly during the Revolution. The attitudes of most blacks toward the war depended on their relationships with their white owners or employers. The compilations of the official register mostly exclude the military records of blacks or fail to identify their race.

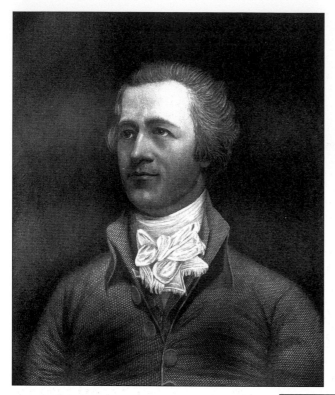

ALEXANDER HAMILTON
(1757–1804). Although not identified as such in early records, Alexander Hamilton was of mixed-race ancestry. He was born in the Leward side of St. Croix Island, British West Indies, to Rachel Fawcett Lavien, a mixed-race woman, and James Hamilton, a Scotsman. During the Revolutionary War, Hamilton distinguished himself in the eyes of Gen. George Washington, who made him one of his six *aides-de-camp* (secretaries) in 1777. Hamilton also rode beside General Washington in the Battle at Brandywine.

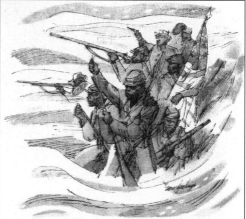

When the War of 1812 broke out between the British and America, many black men enlisted. Free men to further the cause of freedom for themselves and all men, and slaves to gain their personal freedom. General Stonewall Jackson had this to say of their performance ". . .The American nation shall applaud your valor as your General now praises your ardor." Nevertheless, when the war ended many found themselves forced back into slavery.

In the Civil War Negroes represented one-fourth of the Union Navy and more than 190,000 served in the Union Army. They fought in over 400 battles and more than 38,000 lost their lives to preserve the Union.

Secretary of War Stanton, in a letter to President Lincoln, dated February 8, 1864, wrote ". . .They have proved themselves among the bravest of the brave, performing deeds of daring and shedding their blood with a heroism unsurpassed by soldiers of any other race." Among the many awards they received were several Congressional Medals of Honor.

Black men, too, have fought and died, and continue to fight and die, for the right of all people to life, liberty, and the pursuit of happiness.

BLACKS IN THE WAR OF 1812. In this illustration, artist Tom Feelings (1933–2003) depicts a group of black soldiers at battle during the War of 1812. Blacks from the North fought valiantly on Great Lakes ships. This was the last conflict in which black military personnel would fight in integrated units until the Korean War.

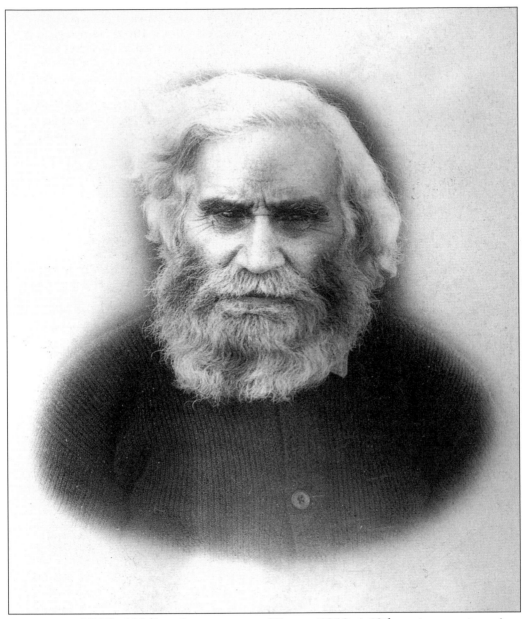

NOAH RABY (1772–1904), A SOLDIER IN THE WAR OF 1812. A 19th-century centenarian, Noah Raby is pictured here in 1901. His father, Andrew Bass, was a full-blooded Cherokee, and his mother, Morning Raby, was of mixed-race ancestry. Raby was born in Gates Court House, North Carolina, and brought to Springfield from Virginia. In an interview, he revealed that he was a soldier in the War of 1812 and served on the U.S. man-of-war *Brandywine* for five years. A longtime servant for the Luther Denman family of Springfield, Raby is buried in the Denman family plot at the Springfield Presbyterian Cemetery.

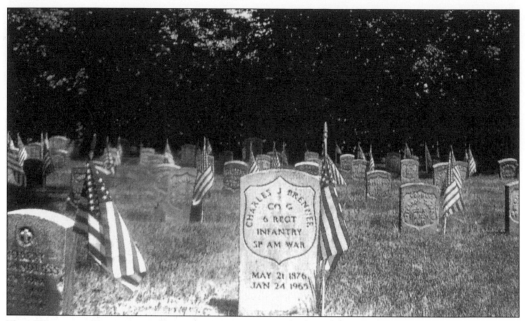

THE HISTORIC EVERGREEN CEMETERY, HILLSIDE. Black soldiers who served their country honorably during the Spanish-American and Civil Wars are interred in a segregated section of Evergreen Cemetery in Hillside. The gravestone of Charles J. Brenner (1876–1965) of Company G, Regiment 6, Infantry Division, Spanish-American War, stands out prominently among other black soldiers buried in section C (near the cannons).

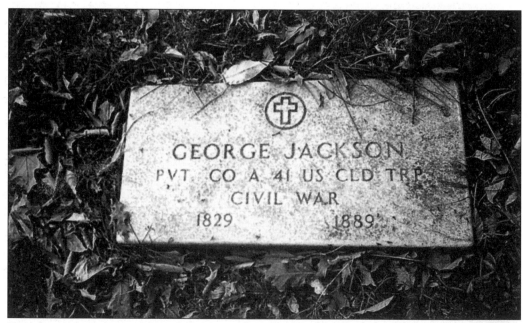

PVT. GEORGE JACKSON. Private Jackson (1829–1889) was trained at Camp William Penn. He served with Company A, 4th Regiment, 22nd U.S. Colored Troop Infantry, which was organized at the camp. His service to his country is noted on his tombstone at Rahway Cemetery.

80

ELIJAH PIPPENGER (1825–1895).
A town crier in Rahway, Pippenger
was born in Ringoes in Hunterdon
County. He moved to Rahway in
1835 at the age of 10. In 1891, writer
H. L. Moore stated of Pippenger,
"His voice is stentorian, yet not
unmusical, and he enunciates very
distinctly and with much emphasis.
His preliminary act is the ringing of
the bell, which act he performs
something like an acolyte swinging
a censer."

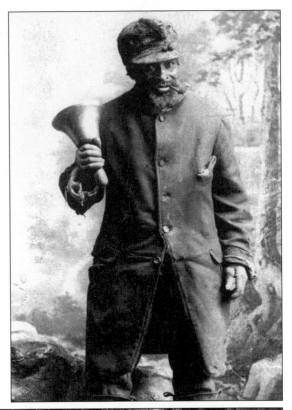

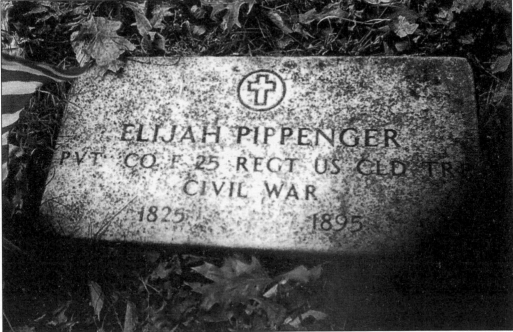

PVT. ELIJAH PIPPENGER. Private Pippenger served with Company F, 25th Regiment, 22nd
U.S. Colored Troops Infantry. He received his infantry training at Camp William Penn
in Philadelphia. His inscribed tombstone is located in Rahway Cemetery.

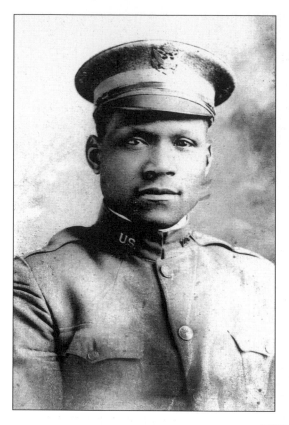

CHAPLAIN DAVID WADSWORTH CANNON (1879–1943). Born into slavery in Concord, North Carolina, David Wadsworth Cannon graduated from Biddle University, attended Lincoln University in Pennsylvania for further study, and graduated from the Princeton Theological Seminary. After serving seven years as pastor of the First Baptist Church in Cranford, Rev. David Cannon resigned in 1918 to become a World War I army chaplain.

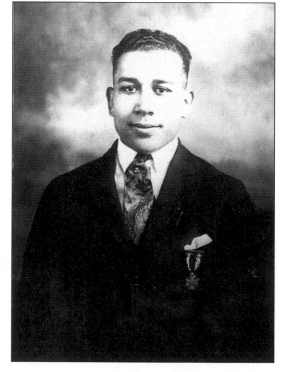

ALBERT HARRIS (1896–1973). A native of Cranford, Albert Harris served in the navy during World War I. Here, he wears the New Jersey Service Medal, awarded to him for two years of honorable military service. During his spare time, Harris pitched and played first base for the all-black Cranford Dixie Giants baseball team.

SHADE MESHACK LEE (B. 1921). Born into the Shady Grove slave community in Daleville, Alabama, Shade Meshack Lee, along with his wife, Mary, settled in Elizabeth in 1961. He began his air force career as a radio operator on B-25 flights, served with the 553rd Army Fighter Squadron, and ended as a microwave engineer. In 1977, Lee retired at the rank of master sergeant. He is pictured here in 1975 at St. Francis Seminary, Staten Island.

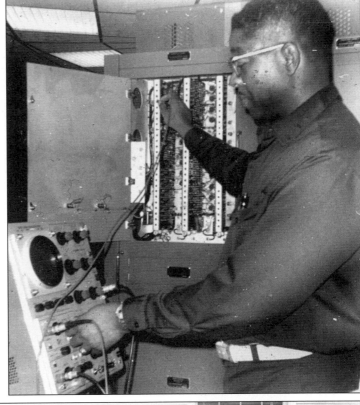

AN AIR FORCE DESEGREGATION PIONEER, 1955. M.Sgt. Shade Meshack Lee poses here (the only black) at the Lockbourne Air Force Base in Ohio. In 1944, while stationed at Waterboro Army Air Base, Alabama, Lee drafted the first integration directive for all federal facilities throughout the United States and all of its territories. Lee's recommendations were cited in the report *Blacks in the Army Air Forces during World War II: The Problems of Race Relations* (1944).

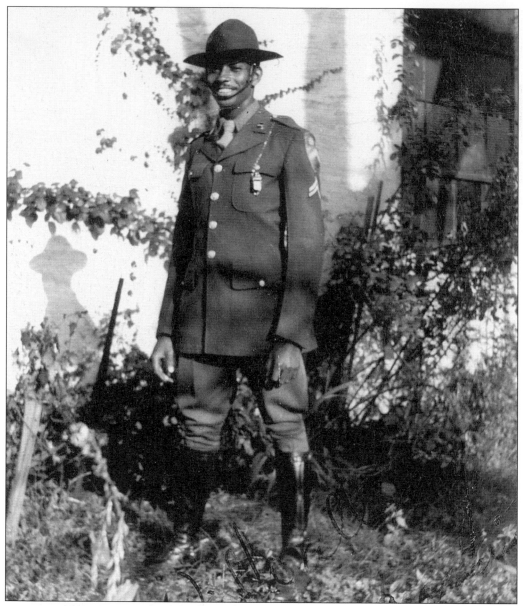

DONALD VAN BLAKE (B. 1921). In 1942, three years after graduating from Plainfield High School, Donald Van Blake enlisted in the armed forces. He was assigned to the 10th U.S. Cavalry, an all-black regiment. The World War II veteran served from 1942 to 1945. Van Blake did his tour of duty in Africa and Italy with the 4th Cavalry Brigade, commanded by Gen. Benjamin O. Davis Sr., the first black air force general. The 9th and 10th Horse Cavalry Regiments, which were comprised of the original Buffalo Soldiers, were formed into the 4th Cavalry Brigade at Camp Funston, Kansas. The Buffalo Soldier regiments were disbanded in 1944. Donald Van Blake, who returned to his native Plainfield after military duty, has been active in the 9th and 10th (Horse) Cavalry Association, which holds annual reunions at different locations throughout the country.

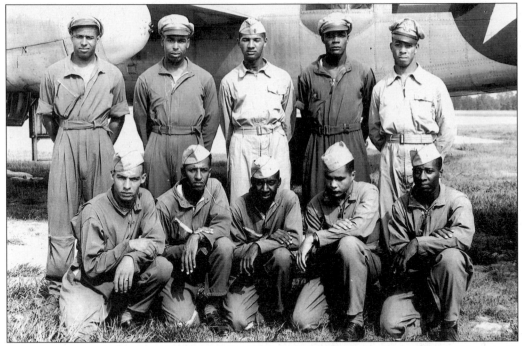

WARREN EDWARD HENRY (1921–1991). Lifelong Plainfield resident 2d Lt. Warren E. Henry is pictured here (kneeling, far left) with other members of Class 44H of the Tuskegee Airmen. The class of black pilots trained at the Tuskegee Army Airfield at Tuskegee Institute, Alabama, which was the training center for the first black pilots to see action with the U.S. Army Air Force. Second Lieutenant Henry served as a pilot in the 477th Bomb Squadron, flying the B-25 bomber.

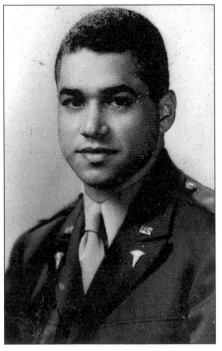

DR. ELBERT POGUE. Elbert Pogue lived and practiced medicine in Elizabeth for many years. A commissioned officer, Second Lieutenant Pogue served as a medic in the U.S. Army Medical Corps during World War II.

THE FIFTH WAR BOND RALLY, 1944. Paul Robeson (1898–1976) returned to his former hometown of Westfield in June 1944 to "sing to a million dollar house" at the Westfield Rialto Theatre. Robeson was the featured performer at Westfield's Fifth War Loan Drive. World II war bond rallies were held around the country in support of U.S. soldiers. The fund-raising quota for the drive was $2 million (see page 43).

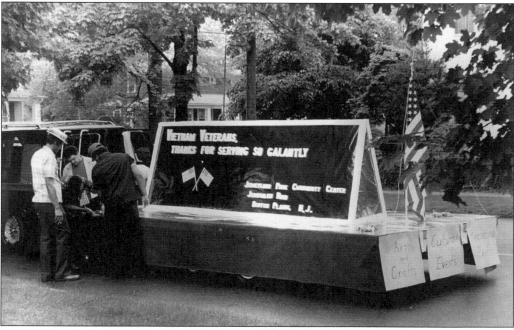

PAYING TRIBUTE TO VIETNAM VETERANS. Members of the Jerseyland black community are shown here with a float designed in honor of the many black soldiers who died while serving their country in the Vietnam War.

A PLAINFIELD SOLDIERS' MONUMENT. This monument, located on the front lawn of Plainfield City Hall, was erected in 2001 and dedicated to Plainfield veterans who lost their lives in World Wars I and II, Korea, and Vietnam. The names of 1,548 soldiers have been chiseled here, including Pfc. James "Frankie" Boyce, the 8th name on the list of 16 Vietnam servicemen killed in combat.

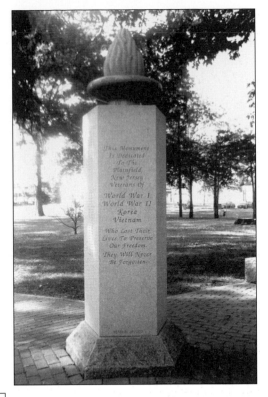

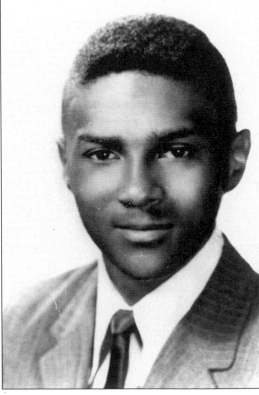

PFC. JAMES "FRANKIE" BOYCE (1948–1969). Musically gifted James "Frankie" Boyce, Plainfield High School class of 1966, began his tour of duty in the U.S. Army on September 13, 1968. On January 20, 1969, Boyce (of the 4th Infantry Division) was killed in Kontum, South Vietnam. In a letter written by Frankie to his parents in November 1968, he stated, "I wish the people of the United States knew what is going on over here and how these people are treating the Negro."

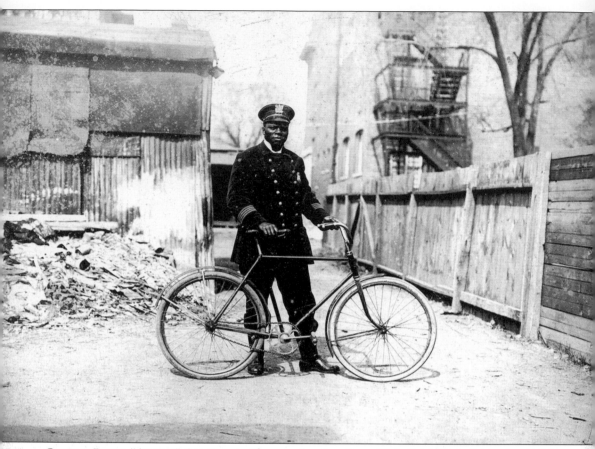

OFFICER JAMES "AUSTIN" SAUNDERS. After graduating from Plainfield High School *c.* 1900, James "Austin" Saunders went on to become the first black police officer in the town. In this 1920s photograph, Sanders wears the police department's uniform as part of the bicycle patrol. The backdrop for this image is Plainfield's old Babcock Building, which was at Front and Duer Streets.

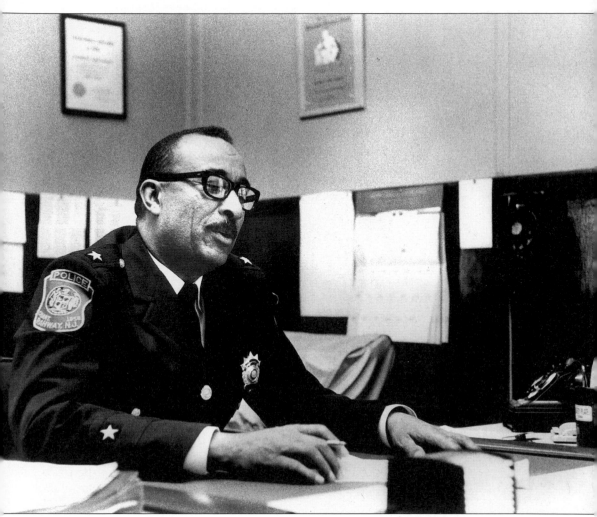

CHIEF HERBERT KINCH. Rahway's first black police chief, Herbert Kinch, is pictured at his desk. A graduate of Rahway High School, Kinch was hired by the Rahway Police Department in 1942. He rose through the ranks of patrolman, 1942; detective, 1952; sergeant, 1953; lieutenant, 1954; and captain, 1959. The Kinch family is among the few black families who can trace their roots in Rahway back to the early 1800s.

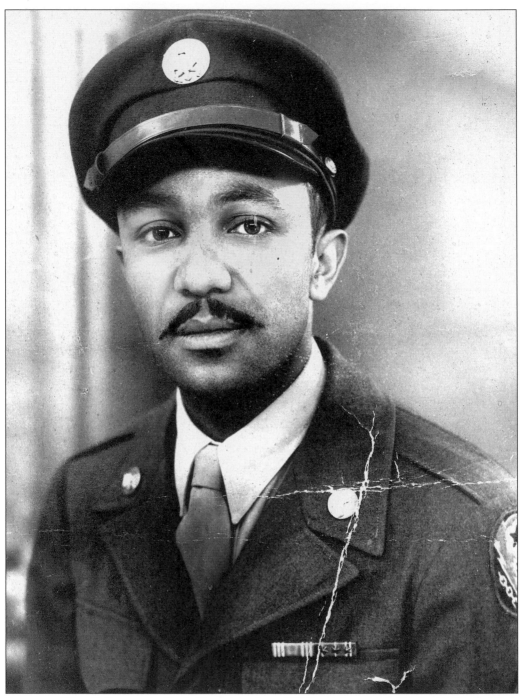

LEONARD "BUD" SIMMONS. Bud Simmons is a 1936 graduate of Abraham Clark High School in Roselle and the Browne Business School of New York. He was the first black policeman in the borough of Roselle, where he later became police commissioner. Simmons, pictured here in military uniform, served in World War II with the 648th Ordinance Company in France, Belgium, England, and Germany. He received five battle stars and two citations for meritorious service in the line of duty (see page 93).

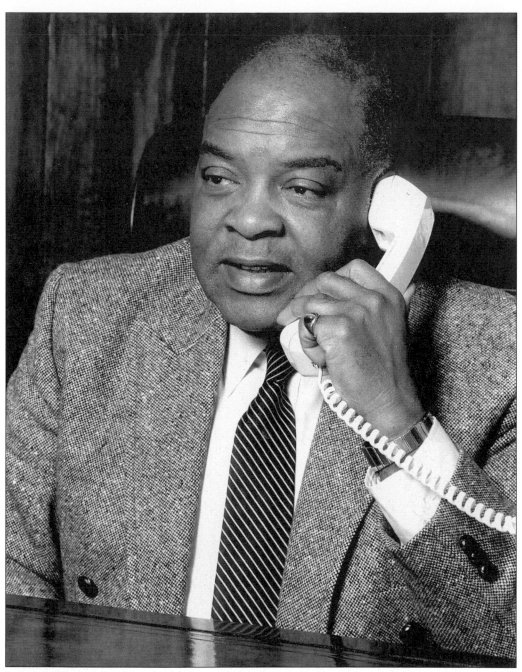

ROBERT W. LEE. A lifelong resident of the Scotch Plains–Fanwood area and a graduate of Scotch Plains High School, in 1956 Robert W. Lee became the first black to serve on the Scotch Plains Police Force. He was appointed deputy state boxing commissioner for the state of New Jersey in 1978, serving under Jersey Joe Walcott. In 1983, Lee founded the International Boxing Federation and was president until his retirement in 2000.

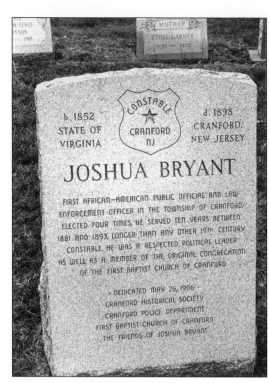

CONSTABLE JOSHUA BRYANT (1852–1898). In 1996, this memorial stone was placed at the previously unmarked grave site of constable Joshua Bryant, the first black public official and law enforcement officer in the township of Cranford. Bryant was elected to this position four times, serving for 10 years between the period of 1881 to 1893. His burial site at Fairview Cemetery in Westfield was located in 1995 after extensive research by the Cranford Historical Society.

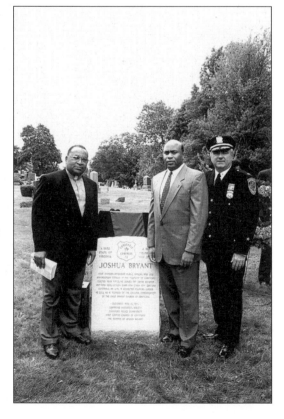

A CRANFORD POLICE FAMILY LEGACY. Chief Eric G. Mason (center) followed in his father's footsteps when he joined the Cranford Police Department. He is shown here with his father (far left), Det. Lt. Milton T. Mason, who was with the department from 1969 to 1997, and former police chief Harry Wilde (far right). Det. Lt. Eric Mason is the current chief of police in Cranford. Chief Mason is also a 1993 graduate of the FBI National Academy.

**SUPERIOR COURT JUDGE AMALYA LYLE KEARSE
(B. 1937).** In 1979, Pres. Jimmy Carter appointed
Amalya Lyle Kearse judge for the U.S. District Court
of Appeals, Second Circuit, in New York. Born in
the Vauxhall section of Union, Judge Kearse
received her bachelor's degree from Wellesley
College in Massachusetts and juris doctorate degree
from the University of Michigan Law School. She
has jurisdiction over interstate commerce cases
covering New York, Connecticut, and Vermont.

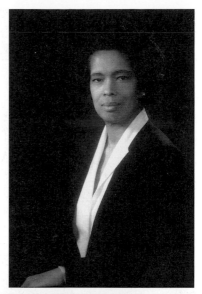

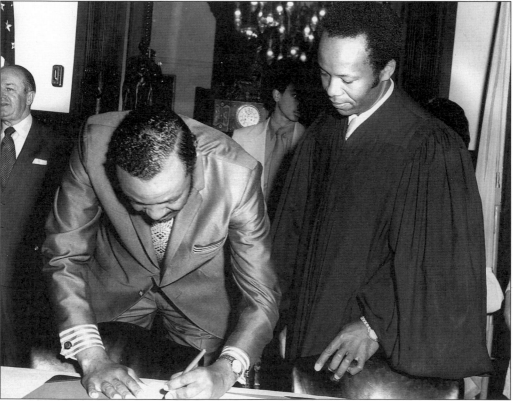

ASSOCIATE JUSTICE JAMES H. COLEMAN JR. (B. 1933). Justice James H. Coleman Jr., a
resident of Scotch Plains, is the first black to serve on the New Jersey Supreme Court.
He was sworn in as an associate justice in 1994, reappointed in 2001, and retired in
2003. He graduated from Virginia State University in 1956 and Howard University
School of Law in 1959. Here, he attends the 1972 swearing-in ceremony of New Jersey's
first lottery commissioner, Leonard "Bud" Simmons.

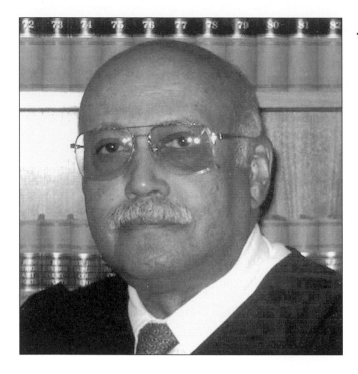

JUDGE RUDOLPH HAWKINS JR. (B. 1933). After graduating from Seton Hall University Law School in 1970, Judge Rudolph Hawkins was admitted to the New Jersey Bar and to practice before the U.S. District Court and the Supreme Court. After serving as judge of the Plainfield Municipal Court for eight years, the Plainfield resident was appointed to the Superior Court in 1985 and assigned to the Family Part of the Chancery Division. Judge Hawkins sat as presiding judge of the division from 1991 to 1997.

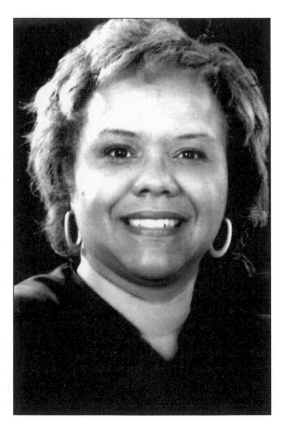

HON. JOAN ROBINSON GROSS. Plainfield High School graduate Joan Robinson Gross was appointed Plainfield Municipal Court judge in 1985. In 1987, she became the presiding judge of the Municipal Court of Union County. Judge Gross, cofounder of the Association of Black Women Lawyers of New Jersey, is the first female municipal court judge in Union County. She is a graduate of Douglass College of Rutgers University (1971) and Columbia University School of Law (1974).

Six

POLITICS AND CIVIC AFFAIRS

REV. FRANK WESLEY ALLEN.
Rev. Frank Wesley Allen's family
roots in Cranford date back to the
19th century. His political activism
began at the age of 17 when he
joined Marcus Garvey's black
nationalist movement, the Universal
Negro Improvement Association. He
later formed the United Plainfield
Housing Commission to obtain
better housing for Plainfield
citizens. In recognition of this, the
Frank W. Allen Village Apartments
were named in his honor. He was
also active in the Plainfield branch
of the NAACP.

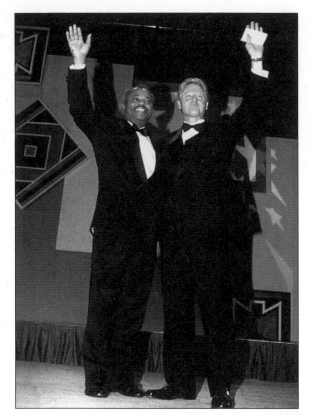

CONGRESSMAN DONALD M. PAYNE AND PRES. WILLIAM J. CLINTON. In 1988, Congressman Donald M. Payne was elected to represent the 10th Congressional District of New Jersey, which includes the Union County towns of Elizabeth, Hillside, part of Linden, Rahway, Roselle, and Union. New Jersey's first black congressman has served continuously since 1988. He is pictured here at President Clinton's 1993 inaugural ball.

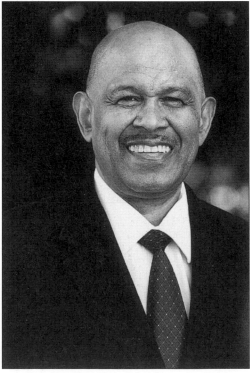

NEW JERSEY ASSEMBLYMAN GERALD B. GREEN. Assemblyman Jerry Green, a lifelong Union County resident, represents the county's 22nd Legislative District in the New Jersey State Assembly and is deputy speaker pro tem for the 2004–2005 session. Prior to his election in 1991, Green served two terms as a Union County freeholder and chaired the freeholder board in 1990.

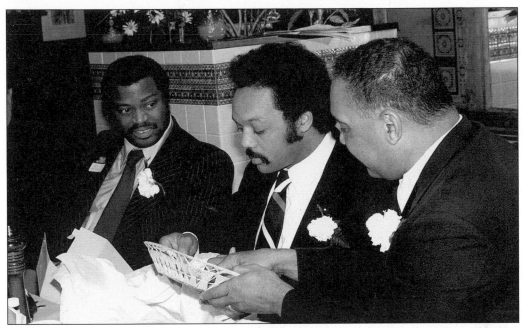

JESSE JACKSON IN UNION COUNTY. During his presidential bids in 1984 and 1988, Rev. Jesse Jackson made several appearances at fund-raising events organized by local Democratic leaders. Reverend Jackson is pictured in the center with former Plainfield mayors Richard L. Taylor (left) and Rev. Everette C. Lattimore.

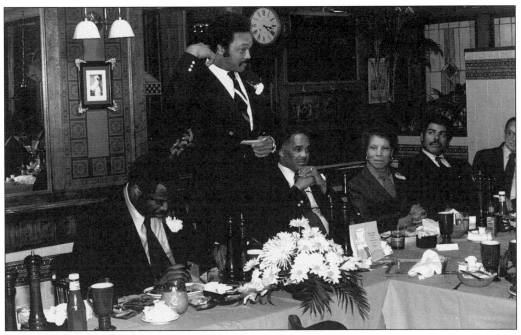

REV. JESSE JACKSON. Former presidential candidate Jesse Jackson carried the predominantly black Democratic town of Plainfield in 1984 and 1988. Here, Plainfield supporters share the head table with the candidate at a fund-raising dinner.

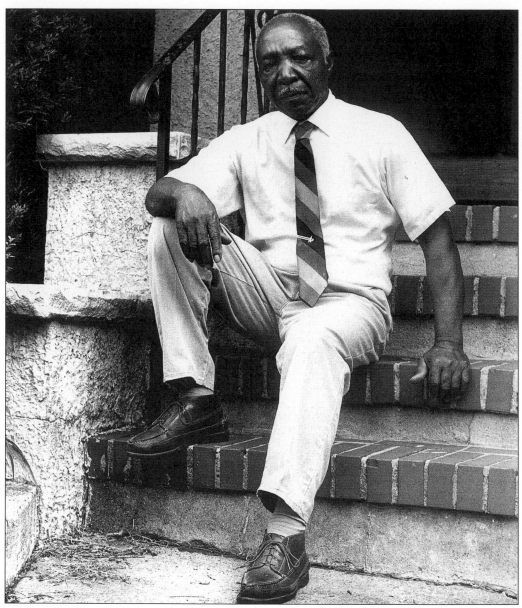

FREEMAN WHETSTONE. The late Freeman Whetstone, a 1940 graduate of Plainfield High School, spent his entire adult life as an advocate for the rights of blacks. After serving in the U.S. Coast Guard during World War II, Whetstone returned to Plainfield to find unfair housing practices and segregated community facilities. He served as a board member of the now-historic black Moorland branch of the YWCA. When the YWCA's building burned down, he worked to get scholarships to the mainstream YMCA for black children. During the 1967 Plainfield riot, Whetstone crossed police lines to bring milk and food to West End residents confined to their homes, while helping to administer a food bank. A life member of the NAACP, Whetstone fought housing discrimination, which he saw as a major problem for blacks. He served as chairman of the Housing Task Force of the Model Cities Program and as president of the South Second Street Neighborhood House.

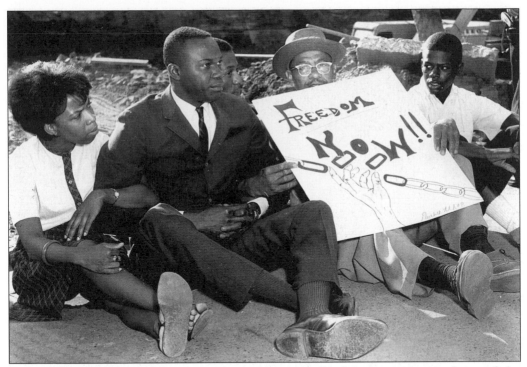

A Peaceful Protest. Elizabeth residents protest unfair labor practices in front of the Elizabethtown Plaza in the 1980s.

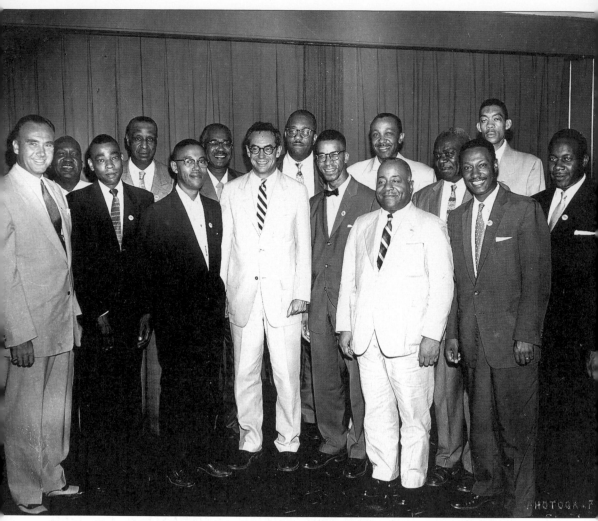

UNION COUNTY AFRO-AMERICAN REPUBLICANS. Originally organized in Roselle as the Union County Black Republicans in 1947, the group changed its name to Union County Afro-American Republicans in 1959. The prominent group of black businessmen on the membership role are shown here in the 1960s with New Jersey Republican Malcolm Forbes (front row, fourth from the left). The group actively supported Malcolm Forbes during his run for governor of New Jersey.

NIDA E. THOMAS (B. 1914). Elizabeth native Nida E. Thomas is a longtime activist who began fighting racial discrimination practices as one of the first staff members of the Urban League of Union County. As director of the New Jersey Office of Equal Educational Opportunity in the Department of Education from 1968 to 1984, she developed the state's first affirmative action plan for education. Thomas was also chief of the Bureau of Integration for the New York Department of Education.

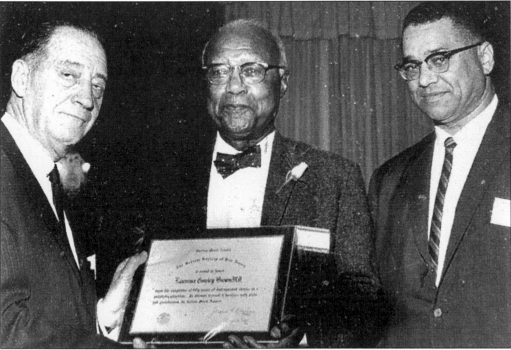

DR. GREELEY BROWN. In 1965, Dr. Greeley Brown of Elizabeth received an award from the Urban League of Union County in honor of his 50 years of service to the community. Pictured here, from left to right, are Dr. Jerome, Dr. Greeley Brown, and Dr. Elbert H. Pogue.

GOV. DOUGLAS WILDER AND ETHEL M. WASHINGTON AT THE BALL. Plainfield resident Ethel M. Washington is shown here with former Virginia governor Douglas Wilder at President Clinton's 1993 inaugural ball in Washington, D.C. Washington attended the ball as a representative member of the New Jersey Black Women's Democratic Political Action Committee. The independent committee, no longer in existence, was established to help elect Clinton president.

THE PRESIDENTIAL INAUGURAL BALL

UNION STATION

JANUARY 20, 1993
7:00 PM

BLACK TIE

NOT VALID FOR RE-ADMISSION
GOOD ONLY AT LOCATION SPECIFIED

THE 52ND PRESIDENTIAL INAUGURAL

AN AMERICAN REUNION
NEW BEGINNINGS RENEWED HOPE

A 1993 INAUGURAL BALL TICKET. Union County residents were well represented at President Clinton's 1993 inaugural ball. Clinton easily carried the black Union County vote, as the area was a mostly democratic stronghold.

Seven

Sports and Leisure

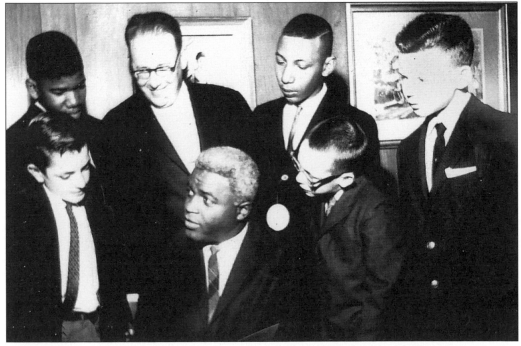

JACKIE ROBINSON IN WESTFIELD. Starting out in the Negro Baseball League, Jackie Robinson became the first black to play in the Major League after signing with the Brooklyn Dodgers in 1945. He was a role model for black youth throughout his career and a regular participant in community events around the country. Here, Robinson is seen during a guest appearance at the Westfield Community Center. During his 10 years in the majors, he played in six World Series games and played every position except pitcher and catcher. In 1962, he became the first black inducted into the Baseball Hall of Fame.

ERNEST E. TYREE, C. 1910. Born in Cranford in 1882, Ernest E. Tyree was a professional caterer who loved the sport of baseball. After World War I, Tyree founded and managed the all-black Dixie Giants. His Cranford home served as the team's headquarters, locker room, and social center.

THE CRANFORD DIXIE GIANTS (1925–C. 1930s). Formed during the period of segregation, the Dixie Giants played their home games at an old baseball field in Cranford. The Dixie Giants regularly played and beat all-white teams in the area.

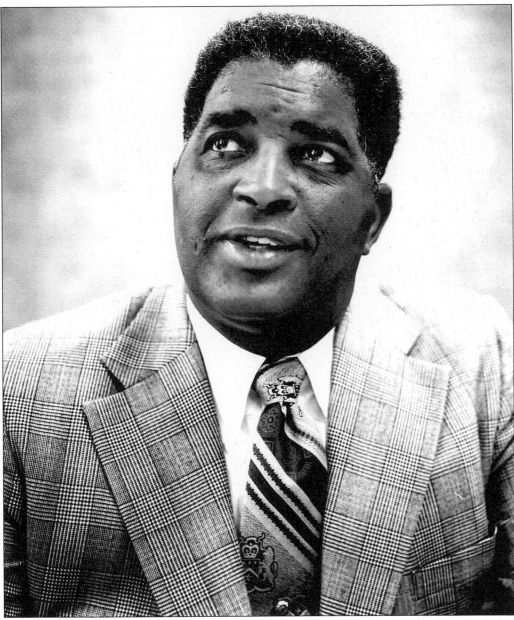

JOSEPH BLACK JR. (1924–2002). Born and raised in Plainfield, Joe Black earned his bachelor's degree from Morgan State University in Baltimore and his master's from Rutgers University in New Brunswick. From 1944 to 1950, he pitched in the Negro League with the Baltimore Elite Giants, posting a record of 44 to 37 in 108 games. In 1952, Black joined the National League as a relief pitcher, remaining there until 1958. With one of the best rookie seasons ever for a pitcher, he was named the 1952 National League Rookie of the Year. After his baseball career ended, Black climbed the ranks of corporate America to become the first black vice president of Greyhound Lines. He became one of the national black community's most recognizable voices through his "By the Way" radio commentary, which reached millions of people on 56 black-oriented radio stations and 40 black newspapers.

Negro American League of Professional Baseball Clubs

Uniform Player's Contract

Parties The.................... Philadelphia Stars Baseball Club

herein called the Club, and.................... Carl Dent

of.................... Elizabeth, N.J., herein called the Player.

Recital The Club is a member of the Negro American League of Professional Baseball Clubs. As such, and jointly with the other members of the League, it is a party to the Negro American League Constitution and to agreements and rules with the Negro National League of Professional Baseball Clubs and its constituent clubs. The purpose of these agreements and rules is to insure to the public wholesome and high-class professional baseball by defining the relations between Club and Player, between club and club, and between league and league.

Agreement In view of the facts above recited the parties agree as follows:

Employment 1. The Club hereby employs the Player to render skilled service as a baseball player in connection with all games of the Club during the year.................... 19 52 including the Club's training season, the Club's exhibition games, the Club's playing season, any all-star games and the Negro World Series, (or any other official series in which the Club may participate and in any receipts of which the player may be entitled to share); and the Player covenants that he will perform with diligence and fidelity and service stated and such duties as may be required of him in such employment.

Salary 2. For the service aforesaid the Club will pay the Player a salary of $.................... 275.00

per month from.................... May 11th to.................... Sept. 1, as follows:

In semi-monthly installments after the commencement of the playing season on the.................... 1st and 16th day of each month covered by this contract, unless the Player is "abroad" with the Club for the purpose of playing games, in which event the amount then due shall be paid on the first weekday after the return "home" of the Club, the terms "home" and "abroad" meaning respectively at and away from the city in which the Club has its baseball field.

If the player is in the service of the Club for part of the month only, he shall receive such proportion of the salary above mentioned, as the number of days of his actual employment bears to the number of days in said month.

Loyalty 3. The Player will faithfully serve the Club or any other Club to which, in conformity with the agreements above recited, this contract may be assigned, and pledges himself to the American public to conform to high standards of personal conduct, of fair play and good sportsmanship.

Service 4. (a) The player agrees that, while under contract or reservation, he will not play baseball (except post-season games as hereinafter stated) otherwise than for the Club or a Club assignee hereof; that he will not engage in professional boxing or wrestling; and that, except with the written consent of the Club or its assignee, he will not engage in any game or exhibition of football, basketball, hockey or other athletic sport.

Post-season Games (b) The Player agrees that, while under contract or reservation, he will not play in any post-season baseball games except in conformity with the Negro Major League Rules, or with or against an ineligible player or team.

Assignment 5. (a) In case of assignment of this contract to another Club, the Player shall promptly report to the assignee club; accrued salary shall be payable when he so reports; and each successive assignee shall become liable to the Player for his salary during his term of service with such assignee, and the Club shall not be liable therefor. If the player fails to report as above specified, he shall not be entitled to salary after the date he receives notice of assignment.

Termination (b) This contract may be terminated at any time by the Club or by any assignee upon five days' written notice to the Player.

Regulations 6. The Player accepts as part of this contract the Regulations printed on the third page hereof, and also such reasonable modifications of them and such other reasonable regulations as the Club may announce from time to time.

THE NEGRO BASEBALL LEAGUE PLAYER'S CONTRACT. Shown above is an authentic copy of the first page of Carl Dent's contract with the Negro American League of Professional Baseball Players. He was signed in 1952.

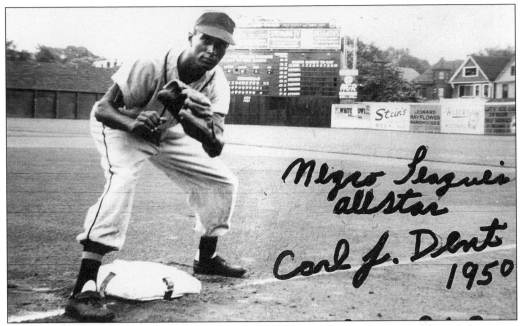

CARL J. DENT (B. 1927). Carl J. Dent moved to Elizabeth in 1946 and began a semiprofessional baseball career. At age 18, manager Buster Haywood signed Dent as a shortstop for the Indianapolis Clowns of the Negro American League. He was considered the "rage" of the team in 1950, his rookie year. Dent was an all-star infielder with the Philadelphia Stars from 1952 to 1955, when the league started folding. He played in Canada until retiring in 1960.

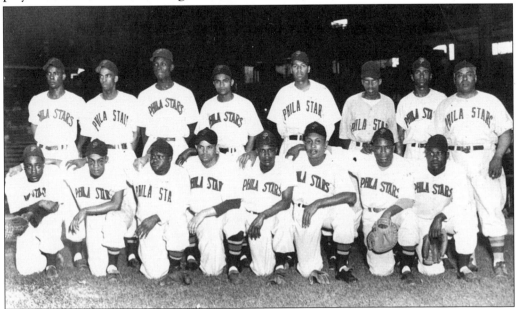

THE PHILADELPHIA STARS BASEBALL CLUB (1933–1952). Carl Dent (fifth player from left, front row) appears here with his Philadelphia Stars teammates. The team originated in the suburb of Darby, Pennsylvania. Originally called the Hilldale Giants, the Stars won the 1934 Negro National League Pennant. The team's owner was Edward Bolden.

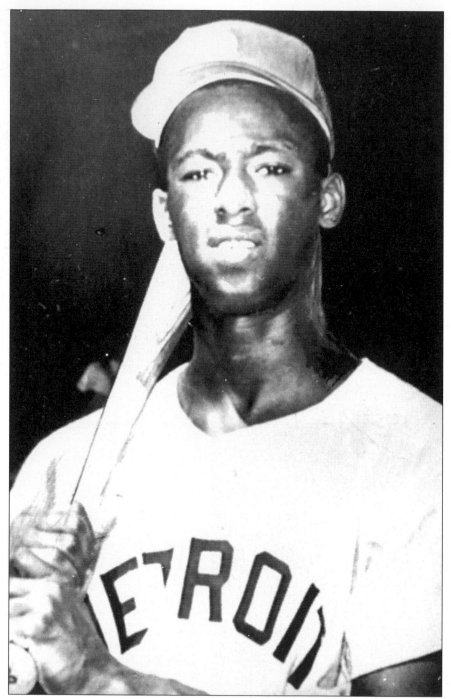

JACOB WOOD JR. Born in Elizabeth in 1937, Jake Wood began his baseball career as an amateur free agent in 1957. Wood entered the major leagues after hitting .300 in all four of his minor-league seasons. He signed with the Detroit Tigers in 1961 and left in 1967 to play his seventh and last season with the Cincinnati Reds. He ended his big-league playing career in 1967.

JOHN SHUMATE (B. 1952). A former standout Notre Dame basketball player, John Shumate grew up in Elizabeth. He was a first-round pick of the Phoenix Suns in the 1974 NBA draft. After Shumate's seven-year NBA playing career ended, he served as an assistant or head coach at several universities, including his alma mater. In 2002, Shumate was named head coach of the WNBA's Phoenix Mercury.

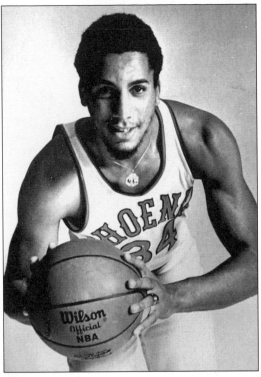

JAY WILLIAMS (B. 1981). A native of Plainfield, Jay Williams was a remarkable basketball player during his four years at Duke University; however, he turned down offers to leave Duke in his sophomore year to play in the NBA. Williams was the Chicago Bulls first-round (second overall) pick in the 2002 NBA draft. A former guard with the Bulls, Williams was seriously injured in a motorcycle accident in June 2003 and officially waived by the Chicago Bulls in 2004.

ROOSEVELT GRIER (B. 1932). In 1951, Roosevelt Grier graduated from Abraham Clark High School in Roselle, where he was a defensive lineman on the varsity football team. On a football scholarship, he attended Pennsylvania State University, where he excelled as a defensive lineman. He spent his professional football career in that same position with the New York Giants from 1955 to 1963 and the Los Angeles Rams from 1963 to 1968. The talented ordained minister is now a singer, songwriter, actor, and activist.

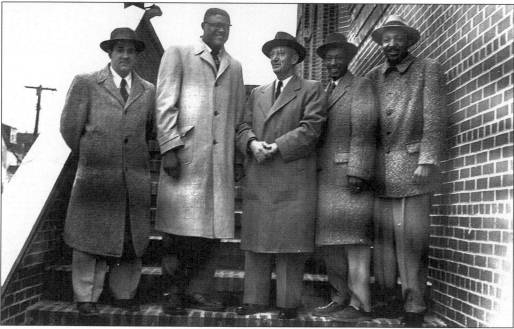

ROOSEVELT GRIER AT PENN STATE. Roosevelt Grier (second from the left) appears here in 1951 with a group of visitors and supporters on the campus of Pennsylvania State University during his freshman year.

EULACE PEACOCK. Eulace Peacock grew up in the Vauxhall section of Union Township. The 1933 Union High School graduate set the New Jersey record for the running broad jump and ran the 100-yard dash in 9.8 seconds. He excelled in track-and-field events at Temple University in Philadelphia and, in 1969, was inducted into the university's hall of fame. He beat his friend, four-time Olympic gold medalist Jesse Owens, 7 out of 10 times in competitive track-and-field events.

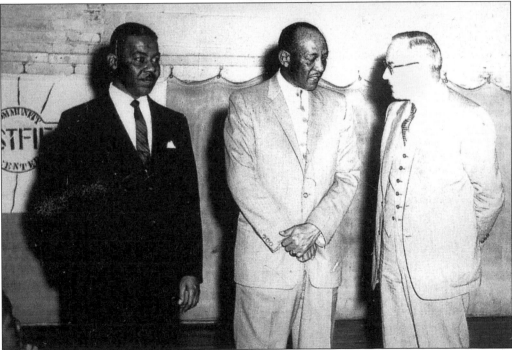

JESSE OWENS (1913–1980). Jesse Owens (center), winner of four gold medals in track-and-field events at the 1936 Olympic Games in Berlin, is seen visiting the Westfield Community Center in the 1960s. Believing that blacks who achieve success "should think in terms of not only himself but also how he can reach down and grab another Black child and pull him to the top," Owens became a celebrated speaker and promoter of youth sports programs.

111

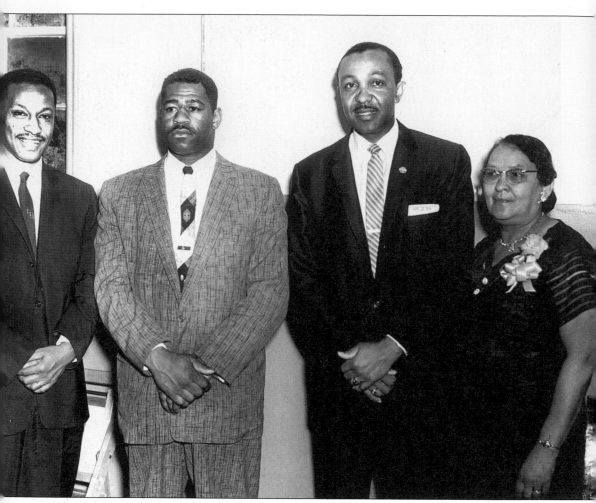

LINDEN BOXER HAROLD CARTER. Harold Carter (second from the left) boxed under the tutelage of Gene Holmes and Willie "Dee" Robinson. Holmes and Robinson were said to be two of the best boxing trainers on the East Coast. They led Carter to the top 10 rankings; he ranked third as a heavyweight contender in 1953. After winning the "gloves" in 1952, he fought in the eastern finals in Madison Square Garden. Carter lost to Floyd Paterson later that year. He is shown here in the 1970s with George G. Woody (far left), Bud Simmons, and Cassie Simmons (Bud's mother).

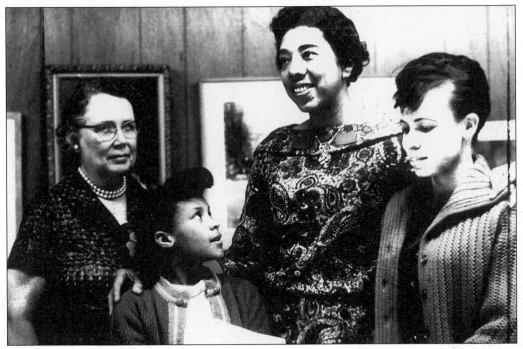

ALTHEA GIBSON (1927–2003). Althea Gibson broke the racial barrier in championship tennis. A frequent visitor to Union County, she is shown here, third from the left, at the Westfield Community Center. Growing up during the era of segregation, Gibson had become a star in the Negro youth tennis leagues in New York by 1943. The two-time Wimbledon champ competed often at the all-black Shady Rest Country Club in Scotch Plains. Gibson was elected to the National Lawn Tennis Hall of Fame in 1971.

DONALD VAN BLAKE (B. 1921) AND WESTRY G. HORNE (1913–2002). Two of Plainfield's outstanding senior tennis players, educators, and community leaders—Donald Van Blake (left) and the late Westry G. Horne—stand shoulder to shoulder at the Donald Van Blake Tennis Courts. A tennis court at the Netherwood Tennis Club was named in honor of Horne, as well as the Plainfield High School auditorium. Van Blake is the high school boys' tennis coach.

Shady Rest Golf and Country Club
(1921-1963) of Scotch Plains
(First Documented Black Owned Country Club)

THE SHADY REST GOLF AND COUNTRY CLUB LOGO, 1921. A group of prominent black investors known as the Progressive Realty Company established Shady Rest Golf and Country Club in 1921, the first black-owned country club in the country. Shady Rest, located in the heart of Scotch Plains's small black Jerseyland community, was a cultural mecca for blacks. Scotch Plains Township assumed operations in 1964, renamed it Scotch Hills Country Club, and turned it into a public golf course.

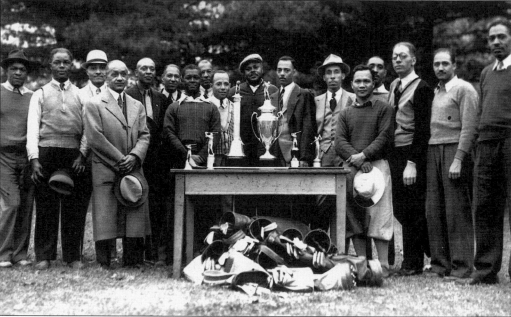

JOHN SHIPPEN AT THE ROYAL GOLF CLUB. John Shippen (fourth from the left) poses with members of the Royal Golf Club of Washington, D.C., *c.* 1930. Shady Rest and the Royal Golf Club were members of the U.S. Colored Golfers Association (USCGA) and were regular host sites for tournaments. The USCGA, now the United Golfers Association, was organized after black golfers were barred from competing in the Professional Golf Association (PGA).

114

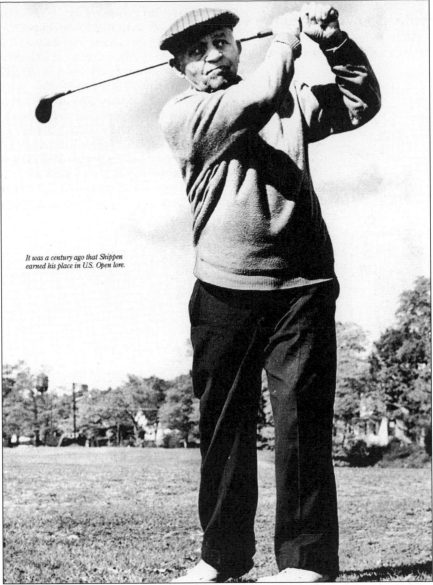

It was a century ago that Shippen earned his place in U.S. Open lore.

AMERICA'S FIRST PROFESSIONAL GOLFER. John Matthew Shippen Jr. (1879–1968) was the first American-born professional golfer to play in a U.S. Open championship. On July 18, 1896, Shippen entered the Second Open Championship at the Shinnecock Hills Golf Club in New York. Several English and Scottish professionals protested and threatened to withdraw if Shippen (a black American) and Oscar Bunn (a Shinnecock Indian) were allowed to compete. U.S. Golf Association president Theodore Havemeyer quickly resolved the issue with a pronouncement that the tournament would be played as scheduled, even if Shippen and Bunn were the only players. Shippen competed in four more U.S. Opens. After several years of competing on the black golfing circuit and a succession of professional jobs at black clubs, in 1931 he became head pro and greenskeeper at Shady Rest Golf and Country Club in Scotch Plains, where he remained until his retirement in 1964. Shippen is buried at Rosedale Cemetery in Linden.

RALPH WISE (B. 1930). In 1950, Ralph Wise graduated from Scotch Plains High School, where he had served as captain of the school's golf club. He holds the distinction of being the last caddy for professional John Shippen, who was, at that time, the resident pro and greenskeeper at Shady Rest. Wise, in conjunction with the Plainfield Recreation Department, has been instrumental in organizing golfing clinics for the town's youth.

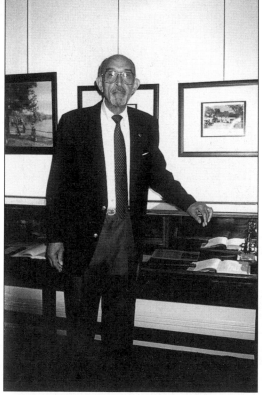

JEFFERSON CRAIG (B. 1924). Jeff Craig excelled at tennis throughout his Plainfield High School years. At the age of 17, Craig was the tennis champion at Shady Rest. He is pictured here at Plainfield's Drake House Museum during the 2004 opening celebration of the exhibition "Little Known Black History Gems of Union County: John Shippen and Shady Rest Golf and Country Club." Author and Plainfield resident Ethel M. Washington was curator of the original 2003 exhibit.

AT PLAY IN THE NEIGHBORHOOD POOL, 1986. These children, living in low-income housing in the West End of Plainfield, happily play in a public pool built in their neighborhood to accommodate their recreational needs.

PING-PONG, C. 1950s. Young Westfield residents are given a Ping-Pong demonstration at the Westfield Community Center.

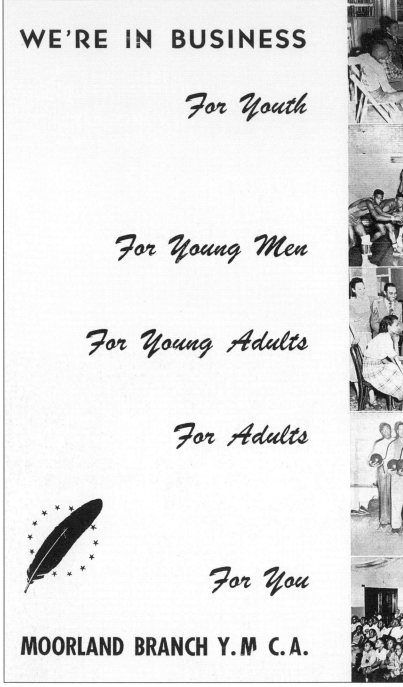

WE'RE IN BUSINESS

For Youth

For Young Men

For Young Adults

For Adults

For You

MOORLAND BRANCH Y.M C.A.

THE MOORLAND BRANCH YMCA. Shown here is the back cover of Moorland's 1952 annual report. The report's author, Cyril C. Lambert, chairman of the committee of management, noted the "solid accomplishments in 1951."

Eight

ALL IN THE FAMILY

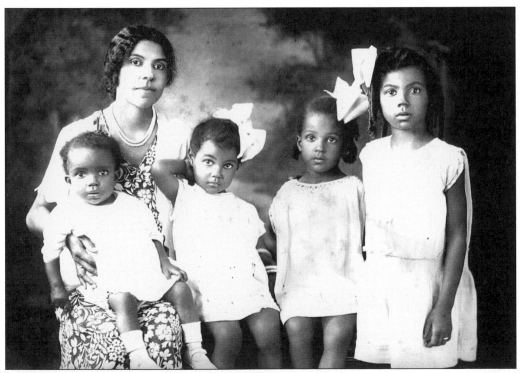

OLIVE MAE BOND POLK WITH HER GIRLS, 1932. Roselle resident Olive Mae Bond Polk poses with her daughters, from left to right, baby Josephine, Barbara, Gene-Ann, and Carolyn. A 1921 graduate of Howard University in Washington, D.C., she was selected New Jersey State Mother of the Year in 1967 by the American Mothers Committee.

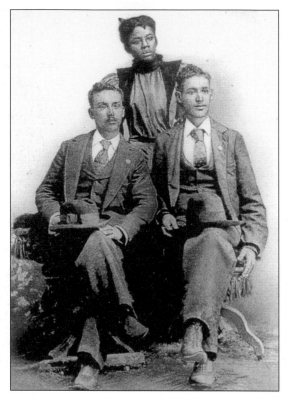

THE PARROTTS OF CRANFORD, *C.* 1900. Between 1885 and 1905, the black population of Cranford increased from 46 to 279. The majority of these newcomers were from the South, especially Virginia. Pictured here, however, are migrants from Sparta, Georgia. From left to right, they are Walter Charles Parrott; his wife, Laura Jones; and his brother William, who chose to return to Sparta.

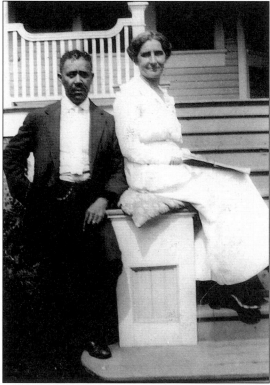

LEMUEL AND IRENE EVANS. A native of Virginia, Lemuel Evans settled in Cranford in 1891 and, eight years later, married Irene Fowlkes. Evans was steward at the Cranford Casino from the time of its opening in 1892 until the building was taken over by the American Legion in 1934. The couple had two daughters, Edith and Ruth. In this 1910 photograph, Lemuel and Irene Evans sit on the steps of the casino.

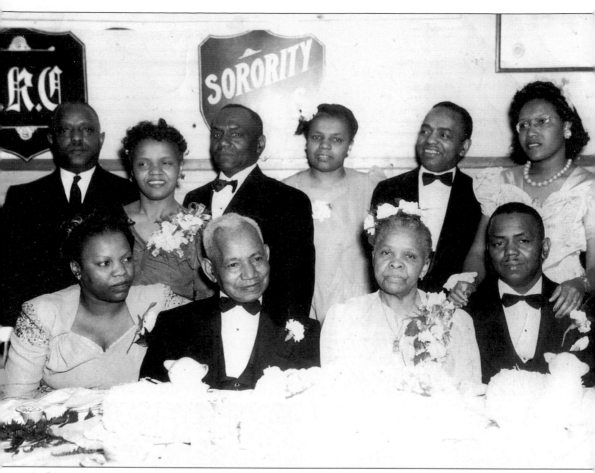

A 50TH GOLDEN WEDDING ANNIVERSARY, 1944. Howard Anthony Sr. and Emma Davis Anthony (seated center) celebrated their 50th wedding anniversary in 1944 surrounded by seven of their eight children and a daughter-in-law. Seated on the left and right of the couple are Elizabeth Anthony Wakefield and George Anthony, respectively. Standing, from left to right, are Edgar, Lavinia, and Napoleon Anthony; Iola Bailey; Howard Jr.; and daughter-in-law Beatrice Anthony, who stood in for the absent daughter, Mae Cuff.

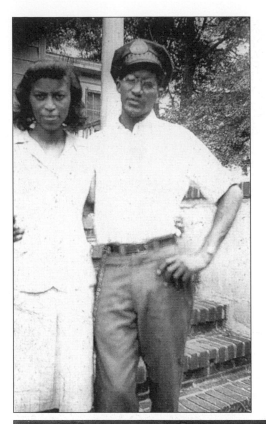

THE GREYS OF PLAINFIELD, *C.* 1940s. Lyndoors (1926–1967) and Thelma (1917–1996) Grey appear in the upper photograph in front of their Raymond Avenue home. The Greys were active in several black organizations, including the Congress of Racial Equality and the National Association of Colored People (NAACP). Lyndoors grew up in Plainfield. A lone black postal worker, he is seated below, to the far right, on a mail truck with his coworkers.

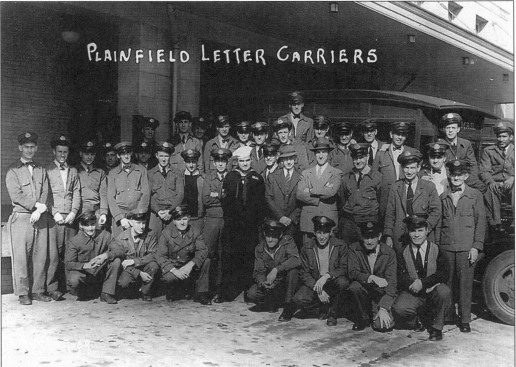

THE POLK FAMILY OF ROSELLE, 1953.
Dr. Charles Carrington Polk and
Olive Mae Bond Polk pose with their
daughters, who are seated according
to age. They are, from left to right,
Carolyn, Gene-Ann, Barbara, and
Josephine. The Polks married in
1920. They lived in Westfield before
settling in Roselle in 1924. Dr. Polk
was named Father of the Year for
1973 at Heard AME Church. All four
girls graduated from Abraham Clark
High School (see page 119).

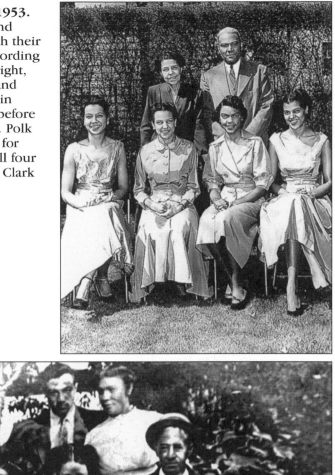

THE MALSON FAMILY OF ELIZABETH. Mary Malson Rice, Elizabeth's first black teacher
(seated center) is shown here with her family members. Pictured from left to right are
the following: (first row) Sarah Jane Malson, Mary, and Edward G. Malson; (second
row) Hamilton Clark and Anne Belle Richards Malson. Mary Rice taught for 15 years
before becoming a full-time wife and mother.

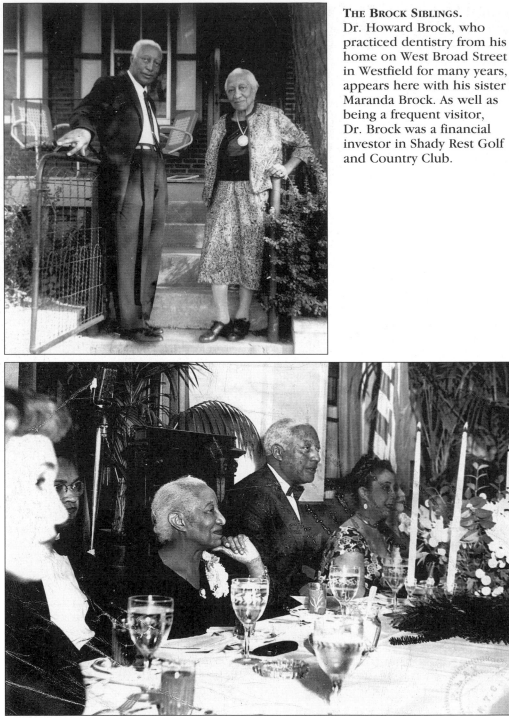

THE BROCK SIBLINGS.
Dr. Howard Brock, who practiced dentistry from his home on West Broad Street in Westfield for many years, appears here with his sister Maranda Brock. As well as being a frequent visitor, Dr. Brock was a financial investor in Shady Rest Golf and Country Club.

A BANQUET AT THE WESTFIELD COMMUNITY CENTER. The Brocks, who moved to Westfield in 1912, were active and well respected throughout the Union County community. Pictured here at a formal dinner are, from left to right, Maranda Brock, Dr. Howard Brock, and his wife, Vivian Brock.

A LATTIMORE FAMILY AFFAIR. Rev. Everett Carrington Lattimore (1927–1991) of Plainfield and Rosetta Norwood of the small black Curryville section of Union, were married in 1950. The couple met as undergraduates at the all-black Shaw University in Raleigh, North Carolina, which was established by the African Methodist Episcopal Church. Rosetta Norwood Lattimore is a retired Plainfield elementary school teacher who continues to do volunteer work in the community. Reverend Lattimore was a clergyman, educator, councilman, mayor, and freeholder. He became Union County's first black mayor when elected to serve Plainfield in 1981, ending 68 years of Republican rule. Here, Reverend Lattimore is sworn in as Union County's first black freeholder in 1970. Rosetta Lattimore stands next to her husband, along with their children, from left to right, Derek, Carl Jeffrey, Dawn, Kirk, and Craig.

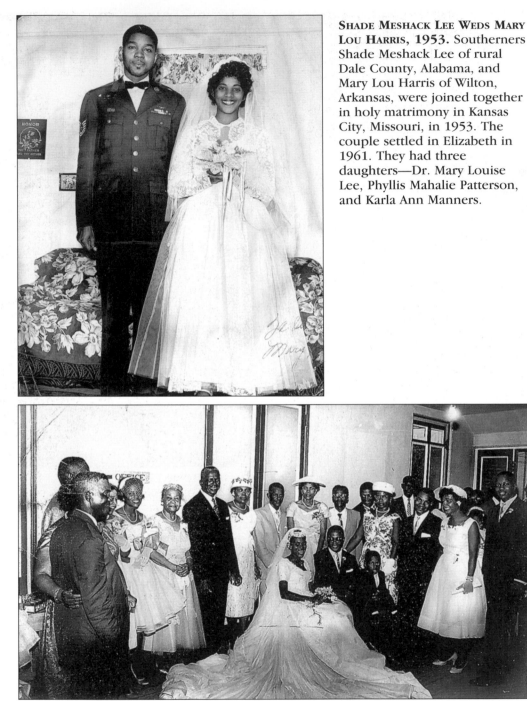

SHADE MESHACK LEE WEDS MARY LOU HARRIS, 1953. Southerners Shade Meshack Lee of rural Dale County, Alabama, and Mary Lou Harris of Wilton, Arkansas, were joined together in holy matrimony in Kansas City, Missouri, in 1953. The couple settled in Elizabeth in 1961. They had three daughters—Dr. Mary Louise Lee, Phyllis Mahalie Patterson, and Karla Ann Manners.

A 1960 WEDDING IN BARBADOS. William Sylvester Weston and Eleanor Ursuline Graham wed in Barbados, where they met, in 1960. The Plainfield couple had a daughter and two sons (see page 69). William Weston earned his bachelor of fine arts in interior design from the Pratt Institute in Brooklyn. He worked as a designer for the Kenmore Furniture Company, Merrill Lynch, and Stephen Leigh and Associates, before becoming an independent design consultant in 1991.

CONGRESSMAN DONALD M. PAYNE AND HIS GRANDCHILDREN. Here, in 2002, U.S. congressman Donald M. Payne of the 10th Congressional District of New Jersey, proudly shows off his grandchildren Shakir and triplets Yvonne, Jack, and Donald III (see page 96).

BIBLIOGRAPHY

Bethel, Leonard L., and Frederick A. Johnson, eds. *Plainfield's African-American: From Northern Slavery to Church Freedom.* Lanham, New York: University Press of America, 1998.

Campbell Jr., Edward D. C., and Kym S. Rice, eds. *Before Freedom Came: African-American Life in the Antebellum South.* Richmond, Virginia: Museum of the Confederacy and Charlottesville, Virginia: University Press of Virginia, 1991.

Fishman, George. *The African American Struggle for Freedom and Equality: The Development of a People's Identity, New Jersey, 1624–1850.* New York: Garland Publishing, 1997.

Franklin, John Hope, and Alfred A. Moss Jr. *From Slavery to Freedom: A History of Negro Americans, 6th ed.* New York: Alfred A. Knopf, 1988.

Fridlington, Robert J. *Union County Yesterday.* Elizabeth, New Jersey: Union County Cultural and Heritage Programs Advisory Board, 1981.

Higginbotham Jr., A. Leon. *In the Matter of Color, Race & the American Legal Process: The Colonial Period.* New York: Oxford University Press, 1978.

Hodges, Graham Russell. *Root & Branch: African Americans in New York & East Jersey, 1613–1863.* Chapel Hill, North Carolina: University of North Carolina Press, 1999.

Honeyman, A. Van Doren, ed. *History of Union County New Jersey: 1664–1923, Vol. II.* Newark, New Jersey: Lewis Historical Publishing, 1858.

Lee, Francis Bazley. *New Jersey as a Colony and a State: One of the Original Thirteen, Vol. IV.* New York: Publishing Society of New Jersey, 1902.

Thayer, Theodore. *As We Were: The Story of Old Elizabethtown.* Elizabeth, New Jersey: Grasman Publishing for the New Jersey Historical Society, 1964.